50 Gems of Cumbria

BETH & STEVE PIPE

AMBERLEY

Acknowledgements

The author and publisher would like to thank Frank Herbert and The Lakes Flying Co. Ltd for permission to use copyright material in this book. Every attempt has been made to seek permission for copyright material used in this book. However, if we have inadvertently used copyright material without permission/acknowledgement, we apologise and we will make the necessary correction at the first opportunity.

Also by the same authors:
Historic Cumbria: Off the Beaten Track

First published 2017

Amberley Publishing
The Hill, Stroud
Gloucestershire, GL5 4EP

www.amberley-books.com

Copyright © Beth & Steve Pipe, 2017

Map contains Ordnance Survey data © Crown copyright and database right [2017]

The right of Beth & Steve Pipe to be identified as the Authors of this work has been asserted in accordance with the Copyrights, Designs and Patents Act 1988.

All rights reserved. No part of this book may be reprinted or reproduced or utilised in any form or by any electronic, mechanical or other means, now known or hereafter invented, including photocopying and recording, or in any information storage or retrieval system, without the permission in writing from the Publishers.

British Library Cataloguing in Publication Data.
A catalogue record for this book is available from the British Library.

ISBN 978 1 4456 6396 8 (print)
ISBN 978 1 4456 6397 5 (ebook)

Map illustration by User Design, Illustration and Typesetting.

Origination by Amberley Publishing.

Printed in Great Britain.

Contents

Introduction	5
North West Region	6
1. Friars Crag	6
2. Ashness Bridge and Surprise View	8
3. Lodore Falls	10
4. Bishop of Barf	12
5. Honister Pass	14
6. Rannerdale Bluebells	16
7. Scale Force	18
8. Whitehaven Marina	20
9. St Bees Head	22
North East Region	24
10. Bowness-on-Solway	24
11. Hadrian's Wall	26
12. Long Meg and Her Daughters	28
13. Lacy's Caves	30
14. High Cup Nick	32
15. The Howk	33
16. Blencathra	35
17. Castlerigg Stone Circle	37
18. Aira Force	38
19. Ullswater & Steamers	40
20. Helvellyn	42
South East Region	44
21. Kirkstone Pass	44
22. Helm Crag	46
23. Grasmere	47
24. Rydal Hall Falls	49
25. Ambleside Lakeland Sports	50
26. Wray Castle	52
27. Tarn Hows	53
28. Orrest Head	55
29. Windermere	57
30. Claife Viewing Station	58
31. Inversions	60
32. Kendal Castles	61
33. Kendal Mountain Festival	63
34. Smardale Gill	65
35. Foulshaw Moss	67
36. Arnside Knott	69
37. Ruskin's View	71
38. Devil's Bridge	73
South West Region	75
39. Herdwick Sheep	75
40. Wast Water	77
41. Scafell Pike	78
42. Cathedral Cave	80
43. Hard Knott Pass and Fort	81
44. Coniston Water	83
45. Duddon Valley	85
46. Ravenglass & Eskdale Railway	87
47. Eskmeals Dunes	89
48. Cumbria Coastal Railway	91
49. The Hoad	93
50. Morecambe Bay	95

Introduction

Choosing fifty gems is always going to be contentious – there is bound to be something that someone thinks we should have included but didn't. That said, we've tried to cover the whole county to tempt you to discover some fantastic places a little further afield. We've also included a number of events rather than just landmarks, and that's because it's these events that help to reinforce Cumbria's unique identity.

Writing books is an absolute pleasure, but it would be far more of a chore without the wonderful support from Cumbria Libraries, Cumbria Wildlife Trust, Kendal Mountain Festival and the Bob Graham Club. We're also indebted to Gwen Moffat for suggesting the glorious Lacy's Caves and The Lakes Flying Co. Ltd for their enthusiasm and generosity.

Writing this book has enabled us to discover some fantastic new places now firmly on our favourites list – Beth writes the words and Steve takes all the wonderful photos. If you want to follow more of our adventures, you can find our blog at www.cumbrianrambler.blogspot.co.uk

North West Region

1. Friars Crag

I like to think that we've included a number of hidden-away gems that are a little off the beaten track. This is not one of those. Friar's Crag, just to the south of Keswick, is home to possibly the most sat-upon bench in the whole of Cumbria, if not the UK. There's a tendency by some to dismiss such popular spots, but there's a reason people go there and, in this case, it's because the views are spectacular.

In Cumbria there are thousands of spectacular views but, in reality, not all of them are accessible to everyone, with some of them involving full-day hikes or arduous climbs. The beauty of Friar's Crag is that everyone can get there; it's wheelchair friendly and it's only half a mile or so from the centre of Keswick.

Friar's Crag bench.

What makes the view so great? Well immediately in front of you is Derwent Water, which sweeps away into the distance and disappears off into the 'Jaws of Borrowdale' – the narrow steep-sided entrance to the Borrowdale Valley. Across the water rise Catbells, Maiden Moor and High Spy, which are perfect if you fancy a spot of hiking, though they're more of a challenge than they look.

If you're in the mood for something a little less strenuous, there's a path that leads from Friar's Crag, which you can follow all the way around the lake – it's around a 10-mile walk but all of it is on flat and easy to follow paths.

The crag takes its name from the monks who left from this point to cross the lake to St Herbert's Island. St Herbert is the saint who brought Christianity to the area in the first century and he lived on the island as a hermit. After he died, the island became a site of pilgrimage and his cell can still be found today – though somewhat covered in undergrowth. The island is accessible if you have a boat but no overnight camping is allowed there.

The area passed into the safekeeping of the National Trust in 1920 following the death of Cardinal Rawnsley, and you'll find a plaque dedicated to his memory along the path to the crag. There's also a memorial to John Ruskin, who described the view as 'one of the three most beautiful scenes in Europe'.

For science fiction fans Friar's Crag has a more modern attraction – this section of Derwent Water featured in the film *Star Wars: The Force Awakens*. In some of the early scenes the Millennium Falcon can be seen swooping along Derwent Water before settling next to a fictional cantina that appears to be very near to Friar's Crag. There was obviously a lot of post-production work done on the film, so it's hard to pin down the precise locations, but if you're familiar with the area, you'll easily spot the landmarks in the background.

Derwent Water.

2. Ashness Bridge and Surprise View

Calling something a 'surprise view' actually takes some of the surprise out of it in my book, rather like knowing there's a twist in a movie – if you know it's coming, it's somewhat less of a surprise. That said, this is a very lovely view, though do be warned if you have either children, vertigo, or both – the edge of Surprise View is a sheer cliff and it's a long way down.

Much of this area is open access land and is criss-crossed by a multitude of footpaths. If you're feeling energetic, you can incorporate the bridge and the view as part of a longer hike, including Bleaberry Fell and High Seat. If you prefer a shorter hike, then hop on the launch from Keswick and walk up from the landing stage at Mary Mount. If you don't fancy either of those, then there's a National Trust car park at Surprise View that you can use and they'll allow you to transfer your parking ticket between there and Wantendlath car park at the top of the hill (though parking is free for NT members).

The views from up here really are quite special. It's the perfect spot from which to see Derwent Water and across to Bassenthwaite Lake. You can also see how the two lakes were once joined many thousands of years ago, and occasionally still are when the area floods. The view continues on, right along the enormous glaciated valley, to the Solway Firth and, on clear days, views of the Scottish hills.

Surprise View.

Ashness Bridge.

As you admire the view, look out for the rooftop of Lingholm, poking up through the trees at the top of Derwent Water. This is the place that Beatrix Potter rented and where she found the inspiration for Peter Rabbit and Squirrel Nutkin. If you're lucky, you may be able to spot red squirrels in the woodland as they have a strong hold here, thanks to an ongoing conservation programme.

Ashness Bridge, on the way up to Surprise View, doesn't have an exciting or chequered history – it's simply a beautiful viewpoint where you can pause awhile and take in what's around you. The bridge is a Grade II-listed packhorse bridge, and the reason the sides of packhorse bridges are so low is because the packhorses had large packs strapped to their sides and low walls on bridges gave them the clearance they needed to get across.

Not far from the bridge is a small memorial to Bob Graham who, in June 1932, first ran what is now known as the 'Bob Graham Round' – a circuit of forty-two fells that need to be completed within twenty-four hours. In 1983 Billy Bland set the record at thirteen hours and fifty-three minutes; at the time of writing that record still stands but keep your eye on the Bob Graham Club website to see if anyone beats it.

From Surprise View it's a relatively easy walk on up the valley to Wantendlath where you can pause again to admire the secluded tarn and grab a bite to eat at the cafe. The village is owned by the National Trust and there's a NT shop here as well as other facilities.

3. Lodore Falls

Some tourist destinations wax and wane in popularity and, although still popular today, Lodore Falls was far busier during the Victorian era when they were an absolute must-see on the grand tour of the lakes.

You'll find them just behind the Lodore Falls Hotel at the bottom end of Derwent Water and there are a few ways to reach them. If you want the nice and easy version, visit the hotel for afternoon tea then take a gentle stroll around the back. They're a short walk from the Mary Mount landing stage if you're coming by boat, or the National Trust car park on the lakeside if you're driving. Alternatively, they're a very short detour if you're tackling a lap of Derwent Water and well worth a visit, especially after heavy rain. There's an honesty box there and a small contribution helps with the maintenance of footpaths, benches etc.

The reason the Victorians were so interested in the falls is because they had been written about by Thomas Gray (1769) and John Keats (1818), been captured on canvas by J. M. W. Turner (1797), etched by Joseph Farington (1816) and were the subject of a superb poem written by Robert Southey in 1823.

Lodore Falls.

The poem in particular is perhaps one of the best examples of the use of the onomatopoeia – words that sound like the sound they're describing, such as 'bang' or 'snap'. It's worth looking up the whole poem for the way it mimics the waterfall by building from a trickle to a crescendo:

> Retreating and beating and meeting and sheeting,
> Delaying and straying and playing and spraying,
> Advancing and prancing and glancing and dancing…

The only problem with these accounts, and in particular the paintings and etchings, is that they tended to overstate the size and magnitude of the falls, which meant that many of the Victorians who subsequently visited ended up being somewhat disappointed. Farington in particular showed Lodore as an enormous swathe of water crashing down over the rocks. Some writers did describe them more accurately but it's possible that the grand descriptions were the ones that caught people's imaginations and became popularised.

Thomas Gray in 1769 claimed that, 'The tremendous roar of the rushing water … can be distinctly heard at a distance of ten or twelve miles.' Whereas in 1797 William Gell had this to say about them: 'I cannot say I was much astonished at the fall, after having seen Scale Force. Indeed it is nowhere properly speaking a fall.'

Cascade of falls.

As with anything that's been overly written about, it's best to visit and make up your own mind. We find them a lovely cool place to visit on a hot sunny day and, if you fancy exploring a little further, there's a small path that climbs up into the woods alongside the falls and offers more interesting views – though do take care as it can be rather slippery.

4. Bishop of Barf

This is one gem I'm going to recommend that you view from afar as Mountain Rescue have been called out many times to rescue people who have become stuck on the steep ground around the Bishop.

The two bright white rocks are just about impossible to miss among the deep green hillside of Barf – look for them on the left just as you're approaching the bottom end of Bassenthwaite Lake. As with many features in Cumbria, their history is wrapped up in folklore and mystery and it goes something like this. In 1783 the newly appointed Bishop of Derry (now Londonderry) was visiting the area and staying at the Sawn Inn at the foot of Barf.

Bishop of Barf.

During the course of his stay (after he had perhaps enjoyed a local ale or two) he took a bet that he could ride his horse up and over the crags to the summit of Lord's Seat (552 metres high and just behind Barf). Unfortunately, during his attempt his horse fell on the steep rocks killing both the horse and the bishop. To commemorate this the patrons of the Swan painted the rock white. The other white rock nearby is known as Bishop's Clerk and marks the spot where the bishop was supposedly laid to rest.

Whatever the veracity of the story, the reality is that the good patrons of the Swan Inn ensured that the rocks were maintained in their resplendent white coats for a fee of 1s and a quart of ale. For many years the painting was done over Spring Bank Holiday by a group of Yorkshiremen from the Territorial Army. Since the Swan Inn closed and was converted into holiday apartments, the new owners have no longer undertaken the maintenance of the Bishop and, despite extensive enquiries, the identity of the current painters remains a mystery. Local rumour suggested it was done by the Keswick Mountain Rescue team, but they assured us it wasn't them!

There is a lovely footpath that winds up onto the top of Barf and, though it doesn't directly pass the Bishop, it is still a beautiful walk offering bird's-eye views of Bassenthwaite below. It's definitely one of the quieter fells to explore and part of a particularly pretty set to complete if you're tackling all of the Wainwrights.

While you're up there, keep your binoculars handy as Bassenthwaite Lake is home to the Lake District Osprey Project, which succeeded in tempting ospreys back to the area in 2001. They nested successfully and have returned every year since. Throughout the summer months they can be seen fishing in the lake in order to feed their hungry chicks.

Bassenthwaite Valley.

If you prefer your excitement on two wheels rather than two legs, then it's definitely worth exploring nearby Whinlatter Forest, which offers a number of interesting and, in places, challenging mountain bike trails.

This is also a great part of the county for pub quiz facts: Did you know that Whinlatter Forest is England's only true mountain forest? Or that Bassenthwaite Lake is the only true lake in the Lake District – all of the others are meres, tarns or waters? Perfect nuggets of information for impressing/boring your friends with on a long walk.

5. Honister Pass

What many visitors see as 'interesting drives' are, for those of us who live up here, essential communication routes. When they close during the winter, as they often do, you could be facing a detour of 100 miles or more to reach your destination, and it's been that way for hundreds of years.

What fascinates me as we cross these routes today is just how easy it is for us now and how hard it must have been back then. We have cars with heaters and possibly four-wheel drive and, if we venture outside, we're clad in layers of thermal

Honister Pass.

clothing, Gore-Tex™ and big fluffy down jackets. Plus today most of us walk the fells because we choose to not because we have to. When these areas were first settled, life was hard and treks across the fells, creating routes such as Honister Pass, were essential for trading with other equally isolated communities.

Even burying the dead could be problematic; in Buttermere, for example, St James' Church is built on rock so the locals had to transport their loved ones to Lorton or Loweswater for burial. In some villages, when this became impossible due to the weather, the coffins would have been stored in an outbuilding, typically in a room without windows, until the weather eased.

The slate mine at the top of the pass faced a number of challenges when it came to transporting the slate. For hundreds of years the slate was loaded onto hand sledges and guided down the valley by 'barrow men' (at least it was downhill!) but even that was only the start of the journey. From the valley floors the slate then had to be transported by packhorse to the Cumbrian coast as boats provided the easiest means for moving such heavy loads around the country. Later tramways were built around the mine and the remains of these can still be seen today.

Honister Pass is a hive of activity for those seeking adventure. There are dozens of walks over the nearby fells, which can be accessed from the pass and a number of high-adrenaline activities on offer at the mine itself.

For a flavour of what things were like when the first motorcars ventured over the pass, watch out for events run by the Vintage Sports Car Club. Each year they organise a hill climb along the steep trail from the slate mine up towards the

Vintage cars.

quarry at Bell Crags. It's quite a sight to see, with the 'youngest' cars having been built around 1937 – and to think that the first time we thought about heading over there in our camper van we chickened out. They don't build them like they used to, do they?

6. Rannerdale Bluebells

Rannerdale is a stunning place to visit at any time of the year but during April and May it becomes extra special. Those of us who live locally scour social media to see who's been up there and whether or not the bluebells are out yet. It's a tricky thing to get right and far from an exact science as they peak for only three or four days before beginning to fade. Those three or four days can also vary enormously from year to year depending on the weather. There are several car parks nearby, which all fill up quickly once word gets out that the bluebells are at their prime.

There are hundreds of bluebell woods in the UK but what makes Rannerdale special is the lack of woodlands; the bluebells carpet a large area of completely

Buttermere.

open hillside. As you make your way along the valley, they first appear as a purple haze hanging low over the field and, stunning as Steve's photos are, nothing compares to the real thing.

There are several well-trodden footpaths through the bluebells and we would very strongly encourage you to stick to those. We were disappointed on our most recent visit to see people trampling over the flowers to get a better angle, creating new paths and destroying more bluebells. If you're after a more interesting shot, then walk a little further along the valley, or perhaps crouch down among them, but please don't damage them.

As with many other places in Cumbria, there's a lot of myth and folklore surrounding the bluebells. A local hotelier, Nicholas Size, published a book in 1930 called *The Secret Valley*. In it he told tales of war-faring leaders and bloody battles taking place along the valley and suggested that the Rannerdale Bluebells sprouted from the blood spilled from a Norman army. The book is certainly an engaging and high-octane account of events and although some of it is rooted in fact, much of it is heavily embroidered.

The reasons for his energetic accounts make more sense when put into context. Sometime around 1920 he bought the Victoria Hotel in Buttermere (now the Bridge Hotel). It had been derelict for a while but he restored and reopened it and had big plans for an alpine-style chairlift to the top of High Crag and a huge beer garden complete with a band, none of which came to fruition. Nicholas was a keen historian as well as a local businessman and

Rannerdale bluebells.

he produced the books in order to drum up tourism for the area. This didn't always go down well with his farming neighbours, who got fed up of visitors trampling all over their fields.

Nicholas, or 'Auld Nick' as he was known, was buried in a stone grave at the head of Fairy Glen, but the stories he created live on, adding yet more colour to an already colourful valley.

7. Scale Force

Scale Force is the highest waterfall in the Lake District and is tucked away beside Crummock Water. The main drop is 52 metres with a further two drops of 6 metres, and although it's tucked away in a tight gorge, it's still an impressive sight, particularly after heavy rain. Wordsworth described it as 'a fine chasm', while his good friend Coleridge said, 'Scale Force, the white downfall of which glimmered through the trees, that hang before it like the bushy hair over a madman's eyes.' Little surprise, then, that this was another firm favourite with Victorian visitors.

The 2.5-mile (4-km) round trip walk to the falls is fairly straightforward these days; the National Trust look after the land and have created a footpath that leads you around to the foot of the falls. The land it crosses is rather boggy and the walk would have been a much more interesting challenge for earlier visitors.

The thing we enjoy most about the falls isn't their lofty height but the variety of colours surrounding you at the base of the falls, especially on a clear day.

Above left: Scale Force main drop.

Above right: Scale Force lower falls.

In addition to the stunning blues and greens of the surrounding fells, there are the deep reds of the rocks surrounding the lower falls, which are accentuated by the foaming and frothing of the beck – it really is one of the most perfect picnic spots in the whole of the county.

There's a rather lovely pencil drawing of the falls in William Gells *A Tour in the Lakes Made in 1797*, which shows the full height of the main drop of the falls but with much less vegetation than we see today, and he describes the falls as 'tremendous and unrivalled' and 'indeed worthy of notice'.

The falls were formed by the erosive power of Scale Beck, which may be small but is very persistent. Since the last ice age this small stream has been falling down from Starling Dodd and working its way back into the rock face. If you look on a geological map (or the iGeology app), you can see how the vertical section has eroded back into the tough granite, creating the narrow gorge we see today.

The beck then continues, tumbling down over bright-red mudstone rocks as the land levels out, and down into Crummock Water. A relic of Ice Age Britain can be found lurking in the icy waters of Crummock Water in the shape of the Arctic Char, which, although rare, thrives nicely in the clear, deep, icy waters of the lake. The particularly clear water also makes it very popular with divers, who can be seen exploring the lake on most days throughout the summer months.

8. Whitehaven Marina

There's so much to see at Whitehaven Marina with plenty of sea walls to wander along and explore. If you follow the steep path up to the 'candlestick' chimney, you can get a bird's-eye view and really see how the different parts of the marina grew and evolved over time. The seats around the 'candlestick' are also the perfect place to sit on a clear day and enjoy the views away over the Solway Firth to Scotland.

The earliest parts of the marina date back to 1633 when the Old Quay was built for the export of salt and coal. During the eighteenth century Whitehaven's prominence as a port grew and so did the marina. By now the town was trading heavily with America, importing tobacco from Virginia and molasses and rum from the West Indies. It was also one of the most important ports in the UK for the slave trade, though no slave ships sailed after 1789 as its remote location made it an uneconomical option.

The second quay (Bulwark Quay) was added in 1711 and the outer harbour and lighthouse were added in 1832, taking twenty-five years to build. By now Whitehaven was equally well known for its shipbuilding as its export trade. The main export during this time was coal and Whitehaven was at the forefront of coal mining technology – the seams were rich and plentiful but also high in toxic gases. King Pit was the deepest mine in the world in 1793 and Saltom Pit extended out under the Irish Sea. (If you're interested in mining history, there are two excellent museums to explore in the town – the Haig Pit Museum and The Beacon).

Whitehaven Marina.

Whitehaven Lighthouse.

By the end of the nineteenth century the railways had arrived to transport the coal around the Cumbrian coast, either heading north through Carlisle or south towards Barrow.

The Queen's Dock was built in 1876 and the original wooden gates were replaced by steel ones in 1938. The final phase was the sea lock, which was added to protect the town from tidal flooding and was completed in 1998.

Sadly, Whitehaven's days as a port of international importance dwindled. Shipping trade ground to a halt by 1790 following the American War of Independence, and shipbuilding ceased in 1889 due to the comparatively shallow waters and remote location. Over 1,000 ships had been built there and many went on to have colourful adventures. One in particular, the *Vicar of Bray*, was involved in the San Francisco gold rush. Today the remains of her hulk can be found in the Falkland Islands, seemingly forgotten, but in 1979 the US National Park Service described it as being 'one of the most important artefacts in US history'.

These days Whitehaven Marina hosts a number of international maritime festivals that bring much needed visitors to this once globally important seaport. It also has very handy shelter that is perfect for keeping the herring gulls away and allowing you to eat your chips in peace.

9. St Bees Head

St Bees is best known among hikers as the starting point for Wainwright's Coast to Coast path, which heads off through the heart of the Lake District before finishing 190 miles (306 km) later in Robin Hood's Bay. The village of St Bees is definitely worth a visit with its ancient priory, assortment of cosy shops and pubs and the wonderful legend of St Bega to get to grips with.

Once you're done exploring the village, it's then time to head for the cliffs – I don't need to direct you; you can't miss them and the footpath winds steadily from the end of the beach, up and along the clifftops. They're the only sea cliffs in Cumbria and are home to a good variety of seabirds. During the early spring and late summer you should be able to spot fulmar, kittiwakes and razorbills as well as several thousand nesting guillemots. It's not just about the birds either. At high tide there's a good chance of spotting seals and the occasional passing porpoise out to sea.

The RSPB have created three separate viewpoints where you can admire the birds and pause to enjoy the views in general. As well as the cliff-dwelling birds, you may also be lucky enough to spot a peregrine racing past, or a skua or sheerwater a little further out.

The lighthouse at St Bees Head was built in 1718 to warn ships of the dangers ahead – at this time Whitehaven, just around the coast, was a busy seaport (*see* 8. Whitehaven Mariana). Sadly this didn't stop a good number of ships running aground and, as they say on the history page for St Bees village, the

St Bees Bay.

Guillemots nesting on St Bees cliffs.

phrase *'burial of unknown man washed up on shore'* occurs time and time again in the burial registers. The detailed accounts of three shipwrecks – the *Luigi Olivari* (1879), the *Truro* (1901) and the *Izaro* (1907) – can also be found on their pages and make for interesting reading.

The shingle beach at Fleswick looks great from the clifftops and is worth pausing to explore as it's said that you can find semi-precious stones in among the pebbles. There may be fewer now than there once were, thanks to the hundreds of treasure hunters before us, but you never know, you might just get lucky.

If you prefer a circular walk to a 'there and back' walk, then loop around from the lighthouse to follow the path through Sandwith Newton and Rottington to St Bees. A tarmac walk doesn't always seem appealing, but this is a quiet and rather lovely woodland road with a pretty little stream running alongside and plenty more opportunities for bird spotting, with dippers usually easy to spot racing along the surface of the water.

North East Region

10. Bowness-on-Solway

The first time we visited Bowness-on-Solway we were on a mission for Cumbria Wildlife Trust who have a nature reserve up there at Drumburgh Moss, which is definitely worth a visit. Many of us are used to exploring the fells and enjoying views of Skiddaw and Blencathra from the south, so it's quite a surprise to head up there and view them from the north for a change – they certainly look a little different and we spent a good few minutes debating which fells were which. Luckily there's a lovely platform in the middle of the moss where you can enjoy the glorious views and debate to your heart's content.

Eden Estuary.

Anyway, back to Bowness-on-Solway, a beautiful if tiny village on the edge of a very big estuary. If you're planning a visit, it's best to check the tides as sometimes, at particularly high tides, some of the approach roads can flood.

These days it's a quiet little village that enjoys huge views across the Solway Firth to Scotland, but it's had its fair share of excitement in the past. It's the starting point for Hadrian's Wall, although there's not much to see these days (*see* 11. for more detail on that one), and it was also once the starting point for an enormous bridge that stretched across the Solway from Bowness to Anan.

The bridge was over 1 mile long and was used by iron ore carrying trains to avoid the busy junction at Carlisle. It was badly damaged by icebergs in 1881 after the rivers Esk and Eden froze then thawed, causing giant blocks of ice to break off and float downstream, demolishing around a third of the bridge. The subsequent enquiry was heavily critical of the use of the cast-iron piers, which, it was felt, were not strong enough to withstand significant shock. When it was rebuilt between 1882 and 1884, the inner piers were still made of cast iron but the outer pillars were made of wrought iron filled with concrete and protected by timber fenders to protect it from further ice damage.

The continually high demands for maintenance on such an exposed bridge, coupled with a decline in railway traffic, meant that the bridge became uneconomical and it closed in 1921, but that wasn't the end of it. At that time you couldn't buy alcohol in Scotland on a Sunday, so each Sunday a number of our Scottish friends crossed the bridge to enjoy a 'relaxing sweet sherry' after dinner in the local Cumberland pubs. Unfortunately they were prone to having one too many and, after a few folks sadly fell from the bridge and

Looking towards Herdhill Scar, site of the bridge to Anan.

drowned making their way home, the bridge was eventually dismantled in 1933. The Highland Laddie Inn, just a short walk from Bowness, has a number of interesting old photographs and additional history on the area.

11. Hadrian's Wall

The most important and possibly the best-known structure built by the Romans during their time in Britain. The first time I saw it my expectations were low – I was expecting little more than a line of grassy rubble – but for something that's getting on for 2,000 years old there's an impressive amount still to see.

It stretches from Bowness-on-Solway in the west to the very aptly named Wallsend in the east (just past Newcastle) and there's a very popular footpath that traces the entire length of the wall. Obviously we don't have the entire wall in Cumbria but we do have some pretty impressive sections.

There are also a number of interesting buildings and remains of building associated with the wall. In Bowness-on-Solway, for example, you won't see much of the wall at all, despite this being the starting point for the walk, but take a visit to St Michael's Church in the village and you'll see why – it was built during the twelfth century using stones robbed from the wall, which was common practice at the time and an excellent early example of recycling.

The wall was built to keep the Scots out and they were serious about it. Along the length of the wall are a series of major forts positioned 8.2 miles (11.5 km) apart, between them are a number of smaller forts, or milecastles, positioned 1 Roman mile apart (1.5 km or just short of our modern mile) and in-between those are a series of turreted lookout posts. Men were stationed at all of these posts and communication ran efficiently along the entire length of the wall using a combination of beacons and semaphore signals.

One of the most interesting sections to visit is the area around Birdoswald where you'll find one of the best-preserved forts. You can walk around the remains of the fort with street patterns and buildings easily visible and excellent information boards to guide you around. Running east from the fort is one of the best-preserved sections of the wall and on a sunny day you can enjoy a gentle stroll alongside the wall and admire the surrounding hills.

If you don't fancy walking the length of the wall, then you can spend the day driving from Carlisle to Haltwhistle, stopping off at each point of interest along the way – and there are many. English Heritage has an excellent parking scheme allowing you to pay once for a ticket that is valid in all the Hadrian's Wall car parks for that day. While you're in the area it's worth taking a short detour to Lanercost Priory, just a few miles from Birdoswald. It was built using stones

Right: Hadrian's Wall.

Below: Birdoswald Roman Fort.

from the wall and the full height remains of the thirteenth-century church still survive and make for an excellent afternoon out.

Following his death in AD 138, Hadrian was entombed in what is now the Castel Sant'Angelo close to Vatican City in Rome.

12. Long Meg and Her Daughters

At 107 metres in diameter, this is one of the largest stone circles in the country. Long Meg is a 3.6-metre pillar of sandstone, stood just outside of the circle, and there are three good examples of rock art on her sides: a series of concentric circles, a spiral and a cup and ring. Her 'daughters' are made of the igneous rock rhyolite.

Mystic Meg.

Based in the east of the county, they are generally a quieter site to visit than other stone circles in the region and easy enough to find as the single-track road cuts straight through the middle of the circle. There are a couple of laybys near to the site allowing easy access, so it's a great place to visit for those who aren't able to tackle a tricky hike.

As with any stone circle, there is a lot of folklore and mystery surrounding the stones. The site probably dates back to around 1500 BC and was most likely created as a part of some kind of religious ritual but, as no one was making detailed written accounts back then, we'll never be 100 per cent sure.

There are the usual stone circle stories of witches being turned to stone, this time for dancing on the Sabbath, and the legend that it's impossible to go around the circle counting the stones and get the same number twice – the same has also been said about Stonehenge and the Rollright stones near Chipping Norton.

During the eighteenth century a local landowner, Lieutenant-Colonel Samuel Lacy, tried to blow up Long Meg with gunpowder so he could plough the field; he failed and the event was followed by a spectacular thunderstorm, which locals took to be Long Meg showing her displeasure. Some people have disputed the date that this happened and suggested it occurred before he arrived in the area, but no one appears to dispute the chain of events – the threat of the stones being destroyed, a big storm and the locals rising up to stand against it.

Meg's Daughters.

The circle is shrouded in ghost stories and strange goings-on with the stones reputed to bring harm or bad luck to those who upset or offend them. These stories aren't just confined to overly dramatic Victorian minds, there are many accounts from people over recent years claiming to see ghostly goings on and at least one account from someone claiming that the energy coming from the nearby wishing tree was so great that they were unable to take a clear photo of it.

A more pragmatic report on the circle was put together in 2013 by the Archaeological Services team at Durham University. They surveyed the site and found evidence of hidden ditches and the possible remains of cairns or barrows in the area (something that had been identified back in the late sixteenth century).

Whichever view you subscribe to, they're certainly a monument worth visiting, though whether you prefer to go there before or after dark is entirely up to you.

13. Lacy's Caves

A visit to Lacy's Caves ties in perfectly with a trip to see Long Meg and her Daughters (see 12. Long Meg and Her Daughters) and there's a lovely circular walk that takes in the two quite easily, looping around Kirkoswald to the north and Little Salkeld to the south. It's not just a walking route that connects them either; Lieutenant-Colonel Samuel Lacy, who reputedly tried to blow up Long Meg, lived in nearby Salkeld Hall and Lacy's Caves are named after him.

He bought the hall in 1790 and, so the story goes, had a batman (an officer's personal servant) who had deserted the army. Rather than report him to the authorities, he put the man to work carving out the caves, which must have been a back-breaking task.

During that time it was quite fashionable to have quirky items on your land – just along the river at Armathwaite in 1855 William H. Mounsey is reputed to have carved a series of five heads into the cliff face, but these are only accessible when the River Eden is running particularly low.

Lacy's Caves comprises five full-height chambers carved into the sandstone cliff face, with one cave leading on from the next and all are easily accessible from the riverside footpath. It is thought that they were created as a place to entertain guests and they once formed part of an ornate landscaped garden, complete with the obligatory rhododendrons – beautiful when in flower but a continual challenge to conservationists.

Colonel Lacy may have been trying to emulate another set of caves further along the river – the caves at Wetheral were carved out by monks during the

View of Lacy's Cave across the River Eden.

Interior of Lacy's Cave.

fourteenth century and were used as a refuge from the regular skirmishes that occurred in the region as the Scottish border was continually disputed.

If you're on the circular walk, there are a couple of other things worth looking out for (and if you're not on the walk, then they're a very short drive away). First of all take a close look at St Oswald's Church in Kirkoswald, parts of which date back to 1130; there's a holy well just outside the west window, which was the original focus of worship. It also has a bell tower that is 183 metres away from the church at the top of a nearby hill. It may have been put here to make it easier to hear and would have been used to summon worshipers to church and also to warn them of any raids from across the border.

In Little Salkeld you'll find one of the country's only remaining water-powered corn mills. Built in 1745, it still produces a range of flours, which it sells on site and through specialist shops across the UK. It's open throughout the year for tours and has an excellent tea room for a rest and refreshment along your walk.

14. High Cup Nick

I first became aware of High Cup Nick when I read *Walking Home* by Simon Armitage – an excellent book charting his progress along the Pennine Way. We'd been meaning to head up there for a while and, next thing we knew, Julia Bradbury was up there on one of her TV specials so we decided to get our skates on!

There's so much about this walk that is fabulous that it's hard to know where to start, so let's tackle it in the order you'll see it when you hike it. First up is the start of the walk in Dufton, where there is a small but perfectly formed car park and plenty of roadside parking, though I'm sure the locals would appreciate it if you parked considerately. There's a map of the route opposite the car park and free toilets – always a welcome sight.

It's known that Romans made good use of the Eden Valley as a transportation route and, although there's no hard evidence, it's thought the village origins may date back to then. There's no church in the village but the parish church of St Cuthbert, just to the south, is thought to be one of the many resting places for St Cuthbert's body as it was carried around the country by Lindisfarne monks evading the Vikings.

The village as we see it today is largely as a result of local lead mining – the London Lead Co. mined and smelted extensively in the area and redesigned the town to accommodate miners, surveyors etc. The prominent water fountain and trough on the village green is one of four that were installed in the village, so no one had far to go for their water.

The route up onto High Cup Nick is a long steady climb with ample opportunities to pause, catch your breath, and admire the scenery. The dramatic and iconic view of High Cup Nick is kept secret until you're almost at the top of the climb, when you suddenly pop out onto one of the high valley sides.

If the valley looks familiar, it's because it has graced many a school geography textbook, being a near perfect example of a glaciated U-shaped valley. The area also reputedly gave the term 'sill' to the world of geology. Local miners and

View of the sill at High Cup Nick.

High Cup Gill.

quarrymen referred to the hard grey layer of igneous dolerite, prominent around the top of the valley, as a sill and the term was later adopted by geologists. It is used to refer to an igneous intrusion that occurs between older layers of sedimentary rocks.

For a different perspective take the path that drops down through the screes at the head of the valley. It's a bit challenging through the top section but the views along the valley floor as the high walls wrap around you are hard to beat. When you reach the end of the track, it's an easy walk in back along the road into Dufton.

15. The Howk

This is genuinely one of my absolute favourite little hidden gems in Cumbria and yet rarely visited by many folks. To find it you'll need to head north from Keswick and follow the signed back road from the A66, through Mungrisdale and Hesket Newmarket (both pretty little places and worth a visit in their own right) and continue on to reach Caldbeck village.

In this part of Cumbria the scenery changes dramatically from the sharp high fells south of the A66 to the rounded masses of Carrock Fell and the Caldbeck Fells. The road is dead straight in many places and has a wild open moorland feel with views that stretch for miles.

You're also deep into red squirrel territory, so have your camera ready. After many months of trying to spot a red squirrel in woodlands and nature reserves, we saw our very first pair sat on a dry stone wall just north of Mungrisdale, watching us as we drove past.

There's a car park in the centre of Caldbeck village and from here The Howk is an easy fifteen-minute, clearly signposted walk. Along the way to the

Howk Bobbin Mill.

The Howk.

falls you'll pass the village duck pond and the remains of The Howk Bobbin Mill. Opened in 1857, it was powered by a 13-metre waterwheel, said to be the second-largest waterwheel in the country at that time. Making use of the surrounding woodland, the mill employed around sixty people and produced bobbins for the cotton mills of Lancashire as well as broom handles, washing dollies and clog soles for the local market.

Just beyond the mill is The Howk, a waterfall in two parts. First are the main falls that have eroded into the surrounding rocks to form a deep, narrow gorge. As you move beyond them, up the steep stone steps, you reach the second part of the falls and a bridge that provides an excellent viewing point. There are plenty of footpaths in the area allowing you to explore the surrounding countryside, most of which are gentle and make for a lovely afternoon stroll.

Once you're done exploring, head back into Caldbeck village and visit St Kentigern's Church, which dates back to 1112 and sits on the site of a sixth-century church. In the graveyard you'll find headstones for John Peel, the infamous Cumbrian huntsman and Mary Harrison, 'The Beauty of Buttermere', made famous by Joseph Budworth in his 1792 book *A Fortnight's Ramble to the Lakes*. Poor Mary had an eventful and publicly humiliating life, which included being

married to a bigamous fraudster who was subsequently hanged. She eventually married a local famer and settled quietly in Caldbeck village where she lived until her death in 1837.

Adjacent to the church is Priests Mill. Once an old corn mill, the buildings have been beautifully restored and are now home to the Watermill Café, which offers a range of delicious local goodies that can be enjoyed on the terrace during the summer or cosied up next to the wood burner during the winter.

16. Blencathra

Arguably one of the prettiest fells in the Lake District, Blencathra stands at 868 metres and looms large over the A66 as you approach from Penrith. It was Wainwright, in his famous series of walking books, that repopularised the name Blencathra; prior to that it was commonly known as Saddleback and, if you see it from a distance, you can see why. Its broad flat ridge of a summit makes it easy to pick out from a distance when gazing north from Helvellyn.

It's certainly one of the more interesting fells with a variety of ascents and descents to explore, and Wainwright wrote more about this fell than any other – not because it was his favourite (that honour went to Haystacks) but because there's just so much to say about it.

Blencathra, also known as Saddleback.

Sharp Edge.

Viewed from the south the assortment of ridges running to the summit are reminiscent of giant flying buttresses propping up an enormous cathedral; but when viewed from the north its appearance softens to an oversized but gently rolling hill. The route up and over Halls Fell Ridge is one of our absolute favourite hikes combining hiking with a little spot of scrambling and immense views all around.

Blencathra is also home to one of the most infamous and challenging routes in the Lake District: Sharp Edge. It's an easy enough walk to Scales Tarn, just below Sharp Edge, along the gloriously named River Glenderamackin ('the river valley of the pig') where you can pause, picnic, and question your sanity as you ponder what lies ahead.

Unless you're a skilled climber with all of the right kit you should only tackle Sharp Edge in good, clear, dry, calm weather – it's made of Skiddaw Slate and as soon as it gets wet it offers roughly the same amount of grip as your average waterslide.

It's one of the most frequented spots by Mountain Rescue, which comes as no surprise to those of us who've crossed it. Even on the best of days it's pretty darned scary with sheer slabs of rock sloping off to the valleys below and very little of anything to hold onto to steady yourself. In wet conditions it is nothing short of treacherous and though some hikers may talk of it as being 'not much of a challenge' with some degree of dismissive bravado, the fact they feel the need to say anything at all about it indicates what a challenge it is.

Once you've reached the summit loop back down and around the top of Foule Crag to follow the footpath along the far side the Glenderamackin. It's a gentle and much quieter track that passes the old lead mines, which were in use from the mid-nineteenth century and closed in 1920. From White Horse Bent there are superb views back along the valley to see Sharp Edge in profile so you can take photos and impress everyone with what you've just done.

17. Castlerigg Stone Circle

If stone circles contain some sort of mystic symbolism relating to the mountains, then it's easy to understand why Castlerigg was constructed in this location. To the north loom Skiddaw and Blencathra, to the south is Castlerigg Fell and the start of a ridge running all the way down to the Langdale Pikes and to the south-east is Clough Head, the start of another ridgeline, this time running all the way down to Helvellyn.

It also has a couple of other claims to fame too: at 5,000 years old it's one of the oldest stone circles in the country and it was the first monument in the country to be recommended for preservation by the state.

It's an easy enough site to locate and reach, either by road or on foot. It lies just to the east of Keswick and has limited parking along the nearby road, though this can get busy during the summer months (it's the most visited stone circle in the county).

There are also a number of circular walks from Keswick and we'd recommend any of the ones that loop out through Castle Wood as the view point at the top is a lovely surprise. As with many other stone circles, the site can get busy on crisp, clear winter nights, when shots of the mountains and stars behind the stone circle are popular with photographers from across the country.

The site is Neolithic in age and contains no formal burials, unlike many later Bronze Age circles. The outer circle is comprised of thirty-eight stones, though again, as with many other stone circles, this number differs and is occasionally recorded as forty depending on what counts as a stone and what doesn't.

The first documented visit to the stones was in 1725 when the clergyman/antiquarian William Stukeley visited and the way he described it back then

Castlerigg stone circle with Blencathra.

Sunset over the mystical stone circle.

is pretty much how we still see it today. Over the millennia some stones may have gone missing (explaining the gaps in the circle) either by falling over and becoming buried or being removed by previous generations who saw no particular significance in the site.

The most unusual feature of Castlerigg is the rectangular formation of stones contained within the circle. Stukeley wrongly surmised that these marked the site of a burial; they don't, but no one is really quite sure what their significance is. There's a similar arrangement of stones at The Cockpit over on Askham Fell but this is the only other example ever found.

Although the site was visited, documented and explored by nineteenth-century archaeologists, very little modern research has taken place here. It's known that the site was a meeting place for Neolithic communities and has some significant astrological alignments, but beyond that little else is known.

The site was bought in 1913 by Cardinal Rawnsley, co-founder of the National Trust. These days the land is still managed by the Trust while the circle is under the watchful eye of English Heritage.

18. Aira Force

Aira Force is a series of waterfalls on land owned and managed by the National Trust along the eastern shores of Ullswater. The falls are on Aira Beck, which tracks an unusual course to the lake. The beck starts out from under the steep sides of Great Dodd and begins by flowing towards the north-east. When it

reaches Dockray the formation of the hills turns the river through nearly 45 degrees until it flows pretty much due south, down towards Ullswater.

The name comes from the ancient Norse word '*eyrr*' meaning 'gravel bank' and refers to the large gravelly run-off area where the beck finally meets the lake. It is now known as Aira Point and is home to a newly created landing stage for the Ullswater Steamers (*see* 19. Ullswater & Steamers).

The falls are perhaps best known for their association with Wordsworth who is said to have been inspired to write his famous 'Daffodils' poem by the daffodils growing around Aira Point.

There's a large National Trust car park at the foot of the falls and two other car parks further up along the road running parallel to the falls. At the lower car park there are a range of facilities including toilets and a recently opened tea room serving a range of local foods.

From the car park there is a clearly marked and very well-trodden path following the beck to the range of waterfalls. The main Aira Force falls are around 20 metres high and plunge down into a narrow ravine. There's a flight of steep steps leading down to the base of the falls for spectacular, if occasionally soggy, views. Down here you'll find a plaque commemorating Cecil Spring Rice, one of two members of the Rice family honoured by bridges over the beck. Cecil's Bridge is the one right at the top of the falls; it was constructed using the traditional Cumbrian building method of vertical stones and was built by friends and family.

Many people head back down from this point but if continue on up the beck, you'll be rewarded with two more sets of falls. The next set are also deep in a ravine and the bridge here is dedicated to Stephen Rice. This bridge is built using a horizontal stone layout more commonly found in the Dales.

Aira Force and Cecil's Bridge.

Aira Beck.

Continue on still further for a third, slightly smaller, set of falls that are much more open. At this set there are a number of broad stone outcrops where you can sit and enjoy a picnic in the sunshine.

Near to the base of the falls, not far from the lower car park, is Lyulph's Tower – a Pele tower originally built by the Duke of Norfolk in the 1770s and used as a hunting lodge. During the nineteenth century the family created an arboretum around the base of the falls made up of trees from all over the world. Many of these trees are labelled today and make an interesting addition to a walk around the falls.

There's also a wishing tree in the woods – a fallen tree that has money pushed into its bark. Tradition says that you can alleviate bad luck or illness by pushing a coin into the tree, but if you take one out, the affliction that affected the original wisher will now come your way.

19. Ullswater & Steamers

Ullswater is often cited as being the most beautiful of all the lakes in the Lake District, which is an impressive accolade given the strength of the competition. It's the second longest of the lakes being around a mile or so shorter than Windermere but, unlike Windermere, Ullswater has a sharp dog-leg bend halfway along, which makes it difficult to get a good view of the whole lake. One of the best views of the lake is from the top of Hallin Fell, just adjacent to Howtown – at 388 metres, it's not too high and there are plenty of easy paths up to the summit.

In 1962 there were plans proposed by the Manchester Corporation to turn Ullswater into a reservoir, as they had with Haweswater and Thirlmere. The plans were fought locally and taken up in the House of Lords by Norman

View of Ullswater from the base of Hallin Fell.

MV *Western Belle*.

Birkett (1st Baron Birkett) who made an impassioned speech prior to winning the vote against the bill. The next day he suffered a ruptured blood vessel in his heart and died the day after. The reservoir may not have gone ahead but United Utilities pumps water from the lake to supplement supplies from Thirlmere during times of drought.

Glenridding at the southern end of the lake is a popular starting point for hikes up Helvellyn and along Striding Edge (*see* 20. Helvellyn), and it's also one of the starting points for the Ullswater Steamers. The first reported steamer on the lake was back in 1859 and the steamers were originally started not just to ferry sightseers, but also to connect the communities along the lake shores.

There are currently a fleet of five yachts with regular sailings along the lake throughout the year and all of the boats are beautifully restored with an interesting history. The oldest, MY *Lady of the Lake*, was launched in June 1877 and is believed to be the oldest working passenger vessel in the world.

In December 2015 Strom Desmond caused extensive flooding in Glenridding and one of the steamers, MV *Lady Wakefield*, was smashed into the pier by the

floods, causing extensive damage. She was deliberately grounded to prevent her sinking and following the floods she was swiftly rescued and repaired, returning to the water in May 2016.

One of the most recent additions to the area has been the creation of the Ullswater Way, a 20-mile (32-kilometre) path circling the entire lake. There has long been a footpath along the eastern shore connecting Pooley Bridge with Glenridding, but in 2016 a path was completed along the western shore to complete the circuit. There are an assortment of flexible steamer tickets available, which enable you to tackle the walk in bite-sized chunks if you don't fancy doing the entire 20 miles in one go.

Both Pooley Bridge and Glenridding were hit hard by Storm Desmond, but both villages are also an excellent example of communities pulling together to enable businesses to reopen swiftly. In mid-March 2016 a community event was organised in Glenridding with volunteers from across the country pitching in to clean all the road signs, add a splash of paint where needed and plant the many hundreds of plants donated by local garden centres in order to get the village ready for the Easter visitors.

20. Helvellyn

Surely Helvellyn is one of the finest fell names; a big solid fell with a big solid name, though the name translates as 'yellow moorland', which feels like a bit of a let-down. It's thought the name refers to the grassy flanks that give the fell a light pastel colour, especially during the winter. Situated in the middle of the Lake District, it's a much more accessible fell than Scafell Pike and the start and end points for the most popular routes are in the picturesque village of Glenridding.

It might be difficult but it's certainly popular. I recently spoke was speaking with a neighbour who told me that during one ascent of Striding Edge, his party sat and ate lunch near the final approach and counted over 1,000 people going past in the space of an hour, which, even with a modest estimate, equates to something in excess of 250,000 people each year – it's no wonder that erosion is such a big issue on the fells.

There are much easier and quieter ascents from the Dunmail Raise side of Helvellyn and we generally head up from Raise Beck to Grisedale Tarn and on to Dollywaggon Pike before the gentle stroll in along the summit ridge. The descent down over Birk Side offers superb views along the Thirlmere Valley.

If you fancy something different, take the descent down via Grisedale Tarn to Patterdale. Not only is it a very lovely descent, it will also take you past the Parting Stone, created by the Wordsworth Society in the late nineteenth century. It marks the spot where William Wordsworth bid farewell to his brother John, who was returning to his job as a sea captain. Sadly he was shipwrecked and

A busy day on Striding Edge.

Red Tarn from Striding Edge.

died. Wordsworth was heartbroken and returned to Grisedale Tarn to compose a poem to commemorate his much-loved brother.

Red Tarn is another of Helvellyn's iconic landmarks and is an almost perfect example of a glacial tarn. Its relatively sheltered position makes it a popular wild camping spot, though hopefully none of the campers try fishing in the tarn, which is home to the rare Schelly fish. The fish is so rare and endangered that in 2002 there was a threat to cull a colony of cormorants that were depleting the stocks to near extinction levels. These days the fish is protected and if one is accidentally caught, it must be released.

Red Tarn is also the final resting place for a Mosquito aeroplane that crashed into Striding Edge on 10 February 1945 with the loss of two lives. The wreckage is still in the bottom of the tarn and each year a number of poppies and crosses are placed next to the tarn in an act of remembrance.

South East Region

21. Kirkstone Pass

This is one of our favourite passes and the one we use the most. It's very handy for a number of our favourite walks – including the route up to Red Screes to see an inversion (*see* 31. Inversions).

Leaving the roundabout at Windermere, the road climbs gently and skirts the edge of Troutbeck village. The valley dropping away to the right has many interesting claims to historical fame. Just before you reach the village the road is crossed by an old Roman road that leads from Ambleside to Brougham, just south of Penrith. It drops gently down into the valley before gradually rising along the flanks of Yoke and Ill Bell and up on to High Street in the distance – named after this ancient road that crosses its summit.

Down in the valley lies Troutbeck Park Farm, which was bought by Beatrix Potter in 1923 after her solicitor husband, William, tipped her off that the

Kirkstone Pass leading to Brothers Water.

farm was coming onto the market and had attracted the attention of property developers keen to convert it into holiday accommodation. Beatrix stepped in purchasing all 1,875 acres and, together with William, set about building her impressive Herdwick sheep farming enterprise – an occupation which utterly absorbed her and drew her away from writing children's books.

Dotted along the road, and tricky to spot from the car, are a number of drinking troughs, which date back to when Kirkstone Pass was a coach road and the poor horses dragging the coaches up and down the pass needed to pause for a drink – there's a particularly nice one opposite Jesus Church as you approach the village.

The Queens Head Inn on the outskirts of the village is a seventeenth-century coaching inn and boasted many original features. Sadly it was gutted by a fire in late 2014 but following a £2-million renovation, it reopened in April 2017.

At the top of the pass there's plenty of space to park and take in the views and, if the mood takes you, enjoy a drink and a bite to eat at the Kirkstone Pass Inn – at 460 metres, it's the highest inhabited building in Cumbria and one of the highest inns in the country.

Not far from the inn is the Kirk Stone, which gives the pass its name. The stone is actually a large boulder that, as you approach the top of the pass from the Ullswater direction, has the appearance of a church tower peeping out above hill crest ('Kirk' deriving from the old Scottish word for church).

Just opposite the inn is the start of The Struggle, a steep and winding road connecting the top of the pass with Ambleside – you may not think it's much of a struggle these days as you cruise to the top in your car, but when the old drovers had to slog up and down it in all weathers, it's easy to understand where the name came from. It's also a bit of a struggle for cyclists and in recent years its formed a part of the Tour of Britain cycle route, though the professional cyclists make easy work of the 1-in-4 incline.

Tour of Britain cyclists tackle The Struggle.

22. Helm Crag

This is surely one of the most distinctive summits in the Lake District. It is often referred to as 'the Lion and the Lamb' because, as you approach it heading north along the A591, the formation on the top resembles a lion lying down with a lamb between its front paws. Wordsworth thought it resembled, among other things, an ancient woman, but for us it's always been 'thumbs up mountain' because as you approach it travelling south along the A591 from Dunmail Raise the rocks on the top resemble a giant hand giving a huge thumbs up.

These distinctive summit rocks are generally referred to as 'The Howitzer' and it's the only time you need to indulge in a little rock climbing to reach the true summit of a Lake District fell. The unusual rock formations at first glance appear to be man-made with their dead straight lines, but it's actually all natural and a quick glance at a geological map of the area explains why (if you don't have a map handy download the iGeology app, it's a brilliant way to understand more about the landscape). They were formed by volcanic andesite rocks intruding into sandstone and the lines we see on the top of the fell exactly match with the geological boundaries marked on the map.

It's infamous in hiking circles as being 'the Wainwright that Wainwright never climbed' – he visited the top of Helm Crag but never tackled The Howitzer, and I can understand why. I chickened out but, as you can see from the photo, Steve was far braver and was soon up on the summit, but it's not for the faint hearted.

Helm Crag is one of the most popular fells in the whole of the Lake District so don't expect to have it all to yourself. There's a beautiful walk out from Grasmere,

The Howitzer.

Looking down over Grasmere from Helm Crag.

along Easedale Beck and up over White Crag to the summit – if you're following that route, it's worth tacking on a short detour to the waterfall at Sourmilk Gill just a little further along the path before continuing on.

At the top you're treated to a 'who's who' of Lake District fells and can pass many happy hours sitting with your OS map arguing over which peak is which. There are also beautiful views over Grasmere to the south and lovely views across to Easedale Tarn in the west – another spot to add to your 'must-visit' list and definitely worth packing a picnic for.

Wainwright was quite disparaging about the descent, recommending that you return the way you went up as the alternate route 'has nothing in its favour', which seems a little harsh. Dropping down towards Helmside, there's a rather lovely zigzag along Green Burn to more waterfalls, followed by a gentle stroll back along a minor road into Grasmere.

23. Grasmere

Grasmere is a typically picturesque Lake District village, full of Cumbrian stone houses and complete with a picture-perfect church and churchyard. Throughout the summer months it is packed with visitors, some of whom just fancy a stroll around the village, others are on the Wordsworth history trail and the energetic ones are setting off on a hike in the fells. Grasmere is one of the starting points for the Fairfield Horseshoe walk, a challenging 10-mile (16-km) hike with spectacular views.

We probably have Wordsworth and his sister Dorothy to thank for the enduring popularity of Grasmere. Born in Cockermouth, he first moved to the village in

Above: Grasmere from Loughrigg Terrace.

Right: St Oswald's Church.

1799, taking up residence in Dove Cottage, now home to the Wordsworth Museum. From there he moved to Allan Bank (these days home to the National Trust), then on to the rectory opposite St Oswald's Church. In 1813 he moved to Rydal Mount, just down the road, where he lived until his death in 1850.

His colourful and evocative poems demonstrate his love for the area and undoubtedly drew in visitors from far and wide. I confess I've not read many of his works but I do enjoy 'The Waggoner', which describes a coach trip up and over Dunmail Raise in foul weather conditions. Grasmere village would have been an important stop along the old coach road and the inns strung out along what is now the A591 would have provided accommodation for passengers and rest or change over spots for the teams of horses.

A stagecoach was a heavy old vehicle requiring a team of four or six horses to pull it. They generally travelled at a steady 5 mph (8 kmph) though the slog up Dunmail Raise would have been considerably slower – hence the need for regular rest stops. The road remained an important coach route through until the 1920s, largely thanks to Wordsworth and his good friend Samuel Taylor Coleridge, who led the fight against a plan to create a railway through the valley connecting Bowness and Keswick.

Each year on St Oswald's Day (5 August) the Rushbearing ceremony takes place in the village. The ceremony dates back to a time when church floors were made of earth and often had parishioners buried beneath them. Worshippers would bring in rushes and other sweet-smelling plants to insulate the floor and maybe help the church to smell a little more pleasant.

Since the advent of flagstone floors, the rushes haven't been needed, but the tradition still continues in this and four other Cumbrian villages (Ambleside, Warcop, Great Musgrave and Urswick). These days the rushes are carried by young girls in traditional dress of white blouse, green smock and straw hat with a garland of flowers. The parade usually draws quite a crowd and winds through the village finishing at St Oswald's Church where each of the rushbearers is given a piece of the famous Grasmere gingerbread.

24. Rydal Hall Falls

If you like your waterfalls small but beautifully formed, then this is the place for you. Rydal Falls is easily accessible for most folks sitting just a few hundred yards behind Rydal Hall (just north of Ambleside). The Rydal Valley is at the centre of the well-known Fairfield Horseshoe walk, which traces the line of the surrounding fells.

A hall has stood on this spot possibly since the second century, but the hall we see today was built in the sixteenth century by Sir Michael le Fleming, head of a powerful and influential Westmorland family. Over the years it was enlarged, with a new frontage added during the nineteenth century. It is a Grade II-listed building and in the 1960s it was sold by the Fleming family to the diocese of Carlisle, who now own and manage the hall.

William Wordsworth lived in nearby Rydal Mount for over thirty years at the end of his life and his poem 'An Evening Walk' describes the falls in such detail that it's clear he spent many hours admiring them.

The footbridge over the top of the falls was built in 1682 by Sir Daniel Fleming and probably replaced an earlier wooden bridge. Clearly a man who enjoyed viewing the falls in all weathers, Sir Daniel went on to build the Grotto (or 'The Grot') at the foot of the falls in 1668/9. He obviously enjoyed a little luxury too as records from the period show that The Grot was panelled and that the wood panelling cost more than the actual building.

The Grot and Rydal Falls have featured in the writings of many visitors over the centuries and the falls were a firm fixture on The Grand Tour, with everyone declaring varying degrees of surprise and delight at the way the large window in The Grot beautifully frames the lower waterfalls. As well as being extensively written about, the view of the falls was captured by Joseph Farington in 1785 and again by John Constable in 1806.

It's worth continuing on up the beck to see the higher falls – just cross over the footbridge and follow the signed footpath. The higher falls are narrower

Rydal Hall Falls and The Grot.

Rydal Falls framed by the window of The Grot.

and higher than the lower falls and, although the footpath becomes a little more challenging beyond the high falls, it's worth pushing on upwards to Buckstones Jum, which is a popular picnic and open-water swimming spot with excellent views back down the valley.

The Coffin Route walk crosses through Rydal and is a fairly gentle but interesting walk that follows the old coffin route from Ambleside to St Oswald's Church in Grasmere. As you near Town End, watch for the point where the Coffin Route meets an old packhorse route; here you'll find a 'coffin' or 'resting' stone where the coffins were set down to give the bearers a rest.

25. Ambleside Lakeland Sports

Throughout the summer, right across Cumbria, a number of 'sports days' are held, with Ambleside and Grasmere being two of the most popular. The traditions date back many hundreds of years and are linked to earlier fairs and other gatherings. Before modern means of communication arrived, these gatherings would have been an essential part of the social calendar for isolated communities and a chance to take the day off from the hard work and meet up with neighbours from other villages.

Ambleside sports can trace their roots back to the seventeenth century when events were held in Low Wood Bay. Activities back then included rowing, cockfighting and bare knuckle boxing. There was a lull in activities until 1886 when, as a precursor to Queen Victoria's Golden Jubilee celebrations, life was breathed back into the event for a number of years before the wars intervened. In these new games there

was less in the way of cockfighting and more sporting activities with events such as wrestling, a 100-yard race, high jump, hurdles and fell running.

Both the Boer War (1899–1902) and the First World War (1914–18) badly affected the event. The games did come back in 1920 for a while before disappearing again until after the Second World War. In 1945 the Hound Trailing Association arranged three trails and a boy's fell race. After the event a meeting was held in the Golden Rule pub in Ambleside where the decision was taken to restart the event and, to honour that tradition, the organising committee still meets in the same place today.

The event has run every year since – including during the foot-and-mouth crisis when a smaller event took place – and it's held in Rydal Park, usually during July. Though steeped in years of history with many traditional events such as hound trails and fell running continuing to form a central part of the day, the organisers have embraced modern cultural shifts too. Children's races were reintroduced in 2002 and in 2016 the first ever Cumbrian Wrestling World Championship for women took place.

Fell running, a traditional Lakeland sport.

Cumbrian wrestling.

Cumbrian Wrestling (or Cumberland and Westmorland Wrestling as it is also known) involves the participants grasping each other in a close hug before trying to unbalance their opponents using a series of throws. If any part of the wrestler, other than their feet, touches the ground then they lose – and if they go down together then the one who hits the ground first loses. (If this is unclear, they simply fight again). The winner of the inaugural women's event was twenty-year-old Connie Hodgson, whose name will now go down in the history books.

If you're visiting the area during the summer months, do look out for one of these sports days for a uniquely Cumbrian experience.

26. Wray Castle

It is always an absolute joy to visit Wray Castle and it's the perfect place for family visits with plenty of activities to entertain the children. The house is a mock-Gothic castle built in 1840 by a wealthy landowner with an interesting approach to architecture – he knew what he wanted but his ideas were often at odds with standard architectural design.

A day at a historic house may not appeal to your average six-year-old but Wray Castle is completely different. There is very little of the original furniture left so the Trust have created imaginative and interactive displays in most of the rooms to enable everyone to learn more about the local history and/or just have fun. The last time we visited there was a full-sized snooker table set up ready for playing, a dressing up room (which even had adult-sized clothes, so no excuses for not joining in), a room given over to showing how drystone walling works (including the chance for you to have a go in miniature) and a camping and kayaking room, which really had to be seen to be believed.

Mock-Gothic towers of Wray Castle.

View from Wray Castle terrace.

The guided tours offered by the Trust give you an excellent insight into the relatively short history of the house. Beatrix Potter stayed there in 1882 when she was just sixteen (her first home in Cumbria, Hill Top, is a short distance away in Near Sawry) and the photographs she took are enabling the National Trust to build a picture of what daily life would have been like.

The house was given to the National Trust in 1929, as Baddeley's *The Lake District* puts it, 'not because of its historical interest, but because of the 64 acres of land surrounding it'. The two main residents since then have been the Freshwater Biological Association (1931–51) and the Merchant Navy who used it as a training college from 1958 to 1998. During the house tours the guides are expert at pointing out the unique marks left on the house by its different residents.

Once you're done with the inside of the house there's all of the grounds to explore, including some lovely small beach areas ideal for picnics or stone skimming contests – or you could just get a snack from the café, sit outside and enjoy the panoramic views of Windermere and the surrounding fells.

Although it's possible to drive to Wray Castle, parking on site is very limited and the surrounding single-track roads become heavily congested, especially during the summer months. By far the best way to visit is to hop on one of Windermere Lake Cruises at either Bowness or Ambleside – you can return via the ferry or take a walk along the shoreline to Claife Viewing Station (*see* 30. Claife Viewing Station) and catch a return ferry from there.

27. Tarn Hows

Tarn Hows is far from the largest lake in the Lake District but if there was a 'visitors per square mile of water' statistic, I'm pretty sure this beauty spot would win hands down. Situated just to the north of Coniston it's a very popular Sunday afternoon walk and is busy with tourists and locals throughout the year. Our favourite route is up alongside Tom Gill waterfall from Glen Mary Bridge – a

View of Tarn Hows.

Ornamental fir trees.

pretty name that was bestowed upon it by John Ruskin (Victorian artist and philosopher) who decided that Tom Gill wasn't a nice enough name.

Don't worry if you're unable to tackle the narrow winding path up through the woods, if you follow the road signs to the tarns, you'll find a number of parking spots, including blue badge bays, and from there the track around the tarn is wheelchair, pushchair and walking frame friendly.

What looks like a wonderful example of a natural landscape was actually carefully designed and created, mainly during the Victorian era. The family responsible for the development of Tarn Hows was the Marshall family, who took over the estate in 1835. They had made their wealth from flax spinning in Leeds and created the landscape we see today by damming three smaller tarns – Low, Middle and High Tarn – to form one large lake and surrounding it with extensive planting of ornamental trees.

In 1930 the Marshall family's estate was broken up and sold on. Beatrix Potter, whose husband William Heelis was the solicitor for the Marshall family,

raised the funds and purchased Tarn Hows in order to protect and preserve it as it was one of her favourite walks. She immediately sold half of it, at cost price, to the National Trust, leaving the remainder to them in her will following her death in 1943.

One of the most well-known local buildings, Brantwood, also formed part of the estate. The house was built in the late eighteenth century but came to prominence when John Ruskin purchased it in 1871 and set about improving and updating it. He bought it for the stunning views of the Coniston Fells, particularly The Old Man, and the landscape has changed little since he lived there.

Tarn Hows is a beautiful place to visit at any time of the year but for us it really comes alive in the autumn where, on a cold crisp day, the golds and deep rich greens of the trees are reflected in the icy calm water. Throughout the years the great and the good have cited Tarn Hows as one of their favourite walks – from Beatrix Potter and William Wordsworth to Dame Ellen MacArthur – and who can blame them when such stunning scenery is backed by Wetherlam and the Coniston Fells.

28. Orrest Head

There are many spectacular views in the Lake District, but few as important as this one. On 7 June 1930 aged just twenty-three, Alfred Wainwright climbed Orrest Head with his cousin and fell instantly in love with the view. It's a feeling many of us can identify with, though few of us have gone on to make our mark on the region in quite the way he did.

You can easily retrace his steps from the station at Windermere up onto Orrest Head. It's a short (twenty-minute) walk from Windermere across a couple of fields then up through a wood and out onto the summit. As soon as you emerge on the top, you can understand why it cast such a spell over Wainwright. As he put it in his book *Ex-Fellwanderer*, 'quite suddenly, we emerged from the trees and were on a bare headland, and, as though a curtain had dramatically been torn aside, beheld a truly magnificent view'. (I do wonder if history may have been somewhat different had it been raining that day...)

It is a very popular spot so you're unlikely to have it to yourself, though there are plenty of benches to go around. From the top there are magnificent views of the Langdale Pikes and pretty much the entire length of Windermere. On one occasion we were up there during the winter and watched a snowstorm blow from Red Screes down and across Ambleside just a few miles away, while we were sat enjoying a flask of hot tea and sandwiches in the winter sunshine.

The Wainwright Society's commemorative plaque.

View of the Langdale Pikes from Orrest Head.

An accountant by profession, Wainwright set about writing the books in the same methodical way he might organise a set of accounts. He divided the Lake District up into regions and had very clear deadlines as to how long it would take him to complete each book. It's hard to believe now but the books aren't printed in some fancy font (that's actually his handwriting) and each page was meticulously drawn and written with any mistakes consigning hours of hard work to the bin. In the early days, before he properly understood the printing process, he produced his pages in actual size, not realising that things could be sized up or down for the finished copy.

He had a reputation for being grouchy but was simply a man who preferred to keep himself to himself on his hikes – a feeling I can well understand when I'm escaping to the fells after a busy week at work. Once you've had your fill of the views, there are a number of fine cafes in Windermere where you can enjoy a good lunch and plan your assault on all 214 'Wainwrights' (though Orrest Head isn't one of them).

29. Windermere

Now there's a lot we could tell you about Windermere: we could tell you that at 10.5 miles (17 km) long (give or take, depending on where you measure it), it's the longest lake in England; we could tell you that at its widest point it's 1 mile (1.6 km) wide; or we could tell you that it contains eighteen islands, the largest of which, Belle Isle, is over half a mile long. We could tell you lots of different things about Windermere but you probably know most of them already.

As the most visited lake in the Lake District and with both Bowness and Ambleside on its shores, there's not a lot about Windermere that people don't already know, so we thought we'd tell you a different story, about how Windermere became the birthplace of British naval and civil marine aeroplanes.

On 25 November 1911 a plane took off from Windermere and became the first aeroplane in the British Empire to successfully take off and land on water. The hydroplane (as it was called) was named *Waterbird* and had been commissioned by Captain Edward William Wakefield, who also piloted it on its first flight.

One of the most important aspects of the hydroplane was the floats, which took a lot of trial and error to get right. Water has a tendency to hang on tight to any flat surfaces so flat-bottomed floats didn't work. Their eventual design, using a steeply stepped surface, was quickly patented. Wakefield then entered into a contract with the Admiralty for his float, and its method of attachment, in order to convert another of their planes – a Deperdussin M1 – into a hydroplane.

The flights were far from popular with some of the locals and objectors included Beatrix Potter and Cardinal Rawnsley. Their protest gathered such momentum that a question was raised in the House of Commons with Winston Churchill (First Lord of the Admiralty) stepping in to say that flying would continue at Windermere.

Sadly, *Waterbird* was written off in March 1912 when a hanger collapsed on her at Cockshott Point (not far from The Glebe). In July 1912 Gertrude Bacon

View down Windermere.

Waterbird in flight. (Credit: Frank Herbert)

became the first woman in the world to fly in a hydro-monoplane when she completed a circuit of Windermere in the Deperdussin.

In November 1914 the lease for Cockshott Point hanger and the remaining hydroplanes was bought by the Northern Aircraft Co. Ltd and in 1916 a Royal Naval Air Station was set up at Windermere. Between 1911 and 1919 fourteen different seaplanes flew at Windermere and there are many excellent archive photos of them to be found on the Waterbird.org.uk website, which is run by The Lakes Flying Co. Ltd. You can also watch their progress as they restore and re-exhibit the original *Waterbird*.

30. Claife Viewing Station

The first time we visited here it was undergoing a major restoration but it's all newly finished now and a great place to visit. It sits on a wooded hillside overlooking Windermere and there are a few ways to get there. A great option is the ferry across from Bowness. There's been a ferry operating around this point on Windermere for over 500 years; it's one of the narrowest points on the lake and so is a natural crossing point. Originally people would have rowed across before human power was replaced by steam power and, as we see today, diesel power.

Alternately there is a lovely walk alongside the lake from Wray Castle (*see* 26. Wray Castle). For England's longest lake there are surprisingly few places where you can walk along the shore for any distance, but the broad track between Wray Castle and Claife Heights makes for a lovely gentle walk or cycle. Of course, if you prefer you can drive there via Far Sawry and

Above: The restored Claife Viewing Station.

Right: Coloured-glass window frame.

there's usually ample parking available, though best to avoid sunny bank holidays unless you enjoy a queue.

It may be popular now but Claife Heights, and this area in general, have been popular for at least 200 years. Visitors have been flocking to the area since the late 1700s and the viewing station was built in the 1790s. The multicoloured windows are designed to represent the different views during the different seasons – yellow for the summer, orange for the autumn, light green for spring and dark blue for the moonlight.

The viewing station is two storeys high with an internal metal staircase and viewing platform replacing the original floors. The colourfully edged windows are perfect for setting up and framing sunny shots down along the lake and watching the boats and ferries coming and going.

The viewing station was a popular party destination for wealthy visitors during the 1830s and 1840s, though folks making their way south along the lakeshore through Graythwaite after dark did so at their peril as 'dreadful boggles' (ghosts) were said to haunt the woods. Those taking the ferry weren't much better off as this was haunted by the 'Crier of Claife' who continually called for the ferryman, before a priest from Lady Holme finally laid the spirit to rest.

As you explore the area, look out for the large round house on Belle Isle – the largest of all the islands in Windermere. The house was built in 1775 but didn't impress Wordsworth who described it as looking 'like a tea canister in a shop window.'

By the end of the nineteenth century the station had fallen from favour and had been left to fall into ruin before life was, thankfully, breathed back into it by the National Trust. There are several interesting walks up into the surrounding woodland, though views of the lake from here are limited due to the trees.

31. Inversions

We've all seen the stunning photos – bright-blue skies and sparkling sunshine with remote fell tops peeking out above the clouds like remote islands in a big white fluffy sea – but inversions are easier to spot than you'd think. They key is to be in Cumbria at the right time of year and keep a keen eye on the weather.

First let's revisit GCSE Geography for those, like me, who may be a little rusty on weather conditions. In the usual scheme of things it gets colder as you get higher meaning you might be warm and toasty in Ambleside but as soon as you head up onto Loughrigg, for example, you'll need your jacket and possibly a woolly hat. Well, a temperature inversion is simply when those temperatures switch places and a layer of cold air in the valleys gets trapped beneath a layer of warmer air above. This cold air will then condense to form clouds, or fog, in the valleys leaving the fell tops sparkly clear.

While most of the photos you may have seen are likely to be haven taken by a hardened hill walker, up at the crack of dawn to catch first light from the top of a remote fell, there are less arduous ways to see an inversion and a couple of places you can head to see them without venturing far from the car.

The trick is to know when one might be occurring so here are the clues. First off they only really happen from late autumn through to early spring, and you'll need to wait for still weather conditions as the wind will just churn up all the temperature layers. A cold clear night with a forecast for a cold clear day ahead is a good start. Set your alarm clock for just before sun up and if, when you peer

Inversion from Red Screes.

Inversion over Windermere from Gummer's How.

out of your window, the world outside has the appearance of Victorian London (the smog, not the men in top hats), then it's likely to be game on.

If you're not a hiker, there are a couple of good places to go to catch a glimpse of this beautiful phenomenon. The first is Gummer's How at the south end of Windermere. As you follow the road upwards you'll pop out of the clouds and just before Gummer's How itself is a free car park with magnificent views across Windermere towards the Coniston Fells.

If you're in the central lakes then head for the top of Kirkstone Pass – just opposite the Kirkstone Inn is a large car park and there are often spectacular views of inversions lying low along the Windermere Valley. If you're up for a trek then follow the nearby route to the top of Red Screes – it's a straightforward hike but do go properly prepared. If you're really lucky and the sun is behind you, watch for a Brocken Spectre where your shadow appears on the clouds below surrounded by a rainbow halo – a very rare and beautiful sight.

32. Kendal Castles

Kendal really seems to miss out when it comes to visitors to Cumbria. It's seen as a shopping centre and not much else but there is a lot of fascinating history associated with the town from the Romans to the wool makers, plus a number of excellent walks along the River Kent (from where the town gets its name – Kent Dale becoming Kendal).

Kendal also has the remains of two castles – both just a short walk from the town centre. The earliest castle, at Castle Howe, is in the east of the town where the remains of an ancient motte-and-bailey castle, dating back to the late eleventh century, are still easily visible.

The second castle, to the west of the town, was built in the early thirteenth century by the Sheriff of Lancaster, and it's likely that the two castles coexisted for a period of time with the second, newer castle acting as more of an administrative base. The sheriff that built it was a rebellious soul who went to war with King John and, following his capture at the siege of Rochester in 1215, the castle was forfeited to the crown.

The castle was returned to the family in 1241 and remained with them for many hundreds of years until it passed, by marriage, to the Parr family, whose claim to fame is that Katheryn Parr became Queen Katheryn (or Catherine – there are various recorded spellings of her name) when she married Henry VIII – she was his final wife, surviving him by a year following his death in 1547.

Although a local school is named in her honour, and it was once thought she may have been born at the castle, this is no longer thought to be true – it is much more likely that she was born and lived in one of the family's other properties in London.

A survey of the castle, which was carried out in 1572, describes it as already being in ruins and indicates that, although it's called a castle, it was actually more of a fortified residence than a military stronghold. Today there are a number of information boards around the site giving more details about the function of the visible rooms and a detailed drawing, based on excavations carried out on the site, which depicts what it may have looked like in its heyday.

Kendal Castle looking towards Longsleddale.

Kendal town from Castle Hill.

To celebrate Queen Victoria's Golden Jubilee in 1897, the Kendal Corporation bought Castle Hill and opened the area to the public. Over recent years the site has undergone significant improvement, including the upgrading of footpaths and improved access to the remaining ruins. For many years it was the site of a spectacular firework display to celebrate Guy Fawkes Night but due to spiralling costs, the future of this is uncertain.

33. Kendal Mountain Festival

Throughout the year there are festivals and events running in every Cumbrian town and many of the villages. Some of these celebrate traditions dating back hundreds of years (for example, *see* 25. Ambleside Sports), some celebrate food and local traditions and others, such as the Kendal Mountain Festival, celebrate the outdoors and adventure.

Kendal Mountain Festival takes place every year over a long weekend in November. It's centred on the Brewery Arts Centre in Kendal, which opened in 1972 in a converted brewery and which, throughout the year, hosts a huge range of festivals, exhibitions, theatre, drama and cinema events. Their VATs Bar is also the perfect place for a beer and pizza night.

Kendal Mountain Festival can trace its routes back to the 1980s when a small group of climbers got together to watch and share a few films. It evolved into its current incarnation in 1999 and since then has been growing in popularity each year – it even has its own UK tour. These days it is recognised around the globe with a rapidly growing centre of operations in China.

One of the centrepieces of the event is the International Film Competition where the very best outdoors and/or adventure films are shown throughout the weekend (usually in excess of 100 films are on offer), culminating in an awards ceremony known unofficially as the 'Oscars of Outdoor Film-making'. A film pass for any of the days of the festival is the perfect way to spend a soggy November day.

They also host the Boardman Tasker Prize for Outdoor Literature – awarded by the Boardman Tasker Charitable Trust to an author, or authors for an original work that has made an outstanding contribution to mountain literature. Previous winners include Joe Simpson's *Touching the Void* and Robert Macfarlane's *The Wild Places*.

On top of all of that there are a range of talks and presentations from leaders in the world of the outdoors with names such as Sir Chris Bonington, Kenton Cool, Cedar Wright, Leo Houlding and Doug Scott all making regular appearances.

There's a marketplace in the grounds of the Brewery Arts Centre where you can check out the latest in mountaineering and outdoors gear, have a go on a climbing wall or just spend time in the café and bar area catching up with friends. At its heart the Kendal Mountain Festival is a social event and the atmosphere is always very relaxed.

The people behind the festival are all outdoors enthusiasts and experts in their field from climbers to skiers and outdoor film-makers, and their passion for what they do is what helps to make the festival the event it is today.

Adventure films from across the world.

A wide range of free talks in base camp.

Events like this aren't gems just because we enjoy them; they're gems because they are an important and integral part of life in Cumbria and, over the course of one weekend, can add something in the region of £2 million to the local economy.

34. Smardale Gill

My love affair with Smardale Gill began when I saw an aerial photo of it on the cover of a Cumbria Wildlife Trust guide. It is a beautiful little hidden-away valley and perfect for a gentle 'after Sunday lunch' stroll. The nature reserve is owned and managed by Cumbria Wildlife Trust and they do a fantastic job. The paths are broad and gentle and the views are magnificent.

We've been up there so many times and there really isn't a bad time of year to visit. There are two options for parking when it comes to visiting the reserve; the first is to park at Newbiggin-on-Lune from where there are a couple of routes over to the reserve, both of which eventually end up following the old railway line. What was once an industrial line carrying iron ore and coke between Durham and the belching furnaces at Barrow is now a rare hay meadow managed using traditional grazing.

The other option is to park in the hamlet of Smardale, though parking is very limited here, and follow the embankment along and into the reserve. Along most

Smardale Bridge over Scandal Beck.

of the route you will see evidence of the conservation work taking place in the area, usually in the form of piles of logs along the sides of the footpaths. Some of these are eventually reused for fuel or path edgings etc., but most are left as a home for bugs, which in turn attract a variety of birds to the reserve.

The valley drops steeply away from the footpath and down to the beck at the bottom – there is a footpath down to the beck but do take care if you tackle it as it is very steep and slippery in places. The vast variety of plant life on the woodland floor, together with indicator species such as Herb Paris, tells us that this woodland probably dates back to the medieval period. During the spring it's full of bluebells and wild garlic with a view that assaults the nose as well as the eyes.

Down along the beck it's easy to spot dippers, with their characteristic white breast, darting back and forth, skimming the surface of the water and dipping in and out to feed on insects and freshwater shrimps. In the woodland you can spot red squirrels and roe dear, both of which are common in the valley, and above the trees circle buzzards and sparrowhawks on the lookout for their next meal.

The centrepiece of the reserve is Smardale Gill Viaduct with its distinctive 14-arch span of the valley. It stands 30 metres high and was rescued from almost certain demolition by the Northern Viaduct Trust, who purchased it from the British Railways Board in the late 1980s, fully restored it and opened it to the public again in 1992. It's now the perfect spot to pause and admire the stunning valley – just so long as you have a good head for heights!

Smardale Gill Viaduct.

35. Foulshaw Moss

Foulshaw Moss is a great place to visit if you want to see what South Cumbria was like before tarmac roads were invented and understand why so many people opted to cross the treacherous sands of Morecambe Bay rather than tackle the boggy wastelands surrounding the Kent Estuary.

During the first part of the twentieth century much of the bog was drained in order to improve communications routes and increase agricultural land. During the 1960s, when the land was owned by the Forestry Commission, it was heavily planted with non-native species, which some people saw as a good thing and remember fondly, but it drove out rare and unique native wetland species of plants and the associated animals.

Cumbria Wildlife Trust (CWT) took over ownership in 1998 and since then they have set about recreating the bog-like habitat that once existed there. This has been a huge challenge to achieve and, in the face of a changing climate, will be an even bigger challenge to maintain.

Above: Boardwalk through the reserve.

Left: Osprey.

 The first thing they did was to remove all of the non-native species and rebuild dams and raised banks to keep the water in. The next step was to replant the site with bog-loving plants and somewhere in the region of 30,000 seedlings have been planted over recent years. As those take a hold, they will enable the land to retain moisture and attract the insects and animals lost when the area was drained.
 There are a couple of notable species whose appearance has highlighted the success of the work done by CWT, the first of which is the White Faced Darter dragonfly. It had been extinct at the site for over fifty years before being reintroduced in 2010, and since then has developed into a stable population – one of only four significant sites for them in the UK. The boardwalks, which guide you around the site, lead to a small pond area and this is a great place to spot them, especially on a warm and sunny June afternoon.

The second notable species is rather larger – the osprey. The first pair nested in 2014 on a purpose-built nest that is situated high in a tree, in the middle of a particularly soggy part of the bog, and was put there specifically to deter would be trophy hunters.

The ospreys usually arrive around the beginning of May and start to hatch chicks by the end of the month. The adults then spend a lot of time hunting for fish to feed and fledge their brood before they all migrate south to warmer climes in early September. At Foulshaw Moss there is a raised platform, which is usually manned by volunteers with powerful telescopes throughout the summer months, where you can get excellent views of the nest. Alternatively, if you don't fancy venturing out, you can tune in and watch them twenty-four hours a day via the Osprey Cam on the CWT website and never miss a moment.

36. Arnside Knott

Arnside often gets forgotten about, tucked away right in the south of the county on the other side of the River Kent, but it's a wonderful place to visit with loads of free parking, great pubs, a superb chippy and excellent rail connections.

Arnside Knott offers some of the very finest views of the fells; on a clear day you can see all the way up to Skiddaw in the far north. Around to the west are the Howgills and the River Kent winding away into the distance and to the east is Morecambe Bay with its vast and ever-changing array of rivers and channels. You don't have to waste time arguing about what you can see as there's a very hand pictorial guide on the viewpoint.

We particularly enjoy including the Knott in a circular walk out from the village, heading along and around the coast and approaching from just behind Hollins Farm. If you're staying in one of the nearby caravan parks, there are numerous public footpaths to follow and explore, each offering a new and unique view of the bay and/or the river and fells. If walking isn't your thing then never fear, you can drive most of the way up Arnside Knott from Silverdale – simply follow the signed route to your right as you head up the steep road out of the village and this will lead you to a free car park that is only a short, albeit steep, walk from the car.

Arnside was once an important setting-off point for trips across the bay and the railway viaduct you see crossing the estuary is built at an old fording point. The sands are treacherous so you may wonder why anyone would risk such a journey rather than following the much safer coast road; well the reality is that prior to the advent of tarmac (a local invention from nearby Trowbarrow Quarry), the coast 'road' would have been a series of muddy tracks crossing a number dangerous bogs – it was simply easier to go across the bay rather than

Above: View of Morecambe Bay from Arnside Knott.

Below: The Kent Viaduct at Arnside.

around it. Even today the rail crossing from Arnside to Grange-over-Sands takes just four minutes and the equivalent journey in a car is closer to thirty minutes.

Arnside itself was once a busy port, exporting gunpowder and importing iron ore for a nearby furnace, but this all came to an end with advent of the railways and the building of the viaduct, which prevented ships from navigating the river.

The estuary is also home to a tidal bore, which occurs on particularly high tides. It's not a high bore like the one seen on the River Severn, but it is pretty impressive to watch the tide come in in one long racing wave, filling the bay and surrounding channels. An alarm is sounded during daylight hours throughout the summer months around two hours before high tide to warn people out on the sands to head for safety.

37. Ruskin's View

One of two gems from Kirkby Lonsdale but so good we just had to include it. Access to the view was greatly improved in 2013 by upgrading the footpath that leads from Devil's Bridge into the centre of the town. From there it's a very pleasant and well-signposted route through the town and out to Ruskin's View.

Folly near St Mary's Church.

Before you reach the view there are a couple of other interesting sights to take in as you make your way through the winding streets. The town was mentioned in the Doomsday Book where it was described as 'Chirchibi' – town with a church. Over the years this evolved into Kirkby with Lonsdale being the name of the valley.

The Church of St Mary in the town dates back to Norman times, with extensions being added during the fifteenth and sixteenth centuries, followed by a full restoration in the late nineteenth century. The market charter was granted for the town in 1227 and markets have continued in the town through to the present day, these days taking place in the market square, which was created in 1820.

Ruskin's View can be found just beyond the church grounds along a footpath high over the River Lune. The view stretches out across the river valley with farmland and gently rolling hills beyond. On a summer's day it's a lovely spot to pause on a bench and just watch the world go by.

In 1816 the artist JMW Turner toured Yorkshire and during that tour he created a number of sketchbooks full of work, including sketches of the Lune Valley and Devil's Bridge. In 1818 he produced *The Lune Valley from Kirkby Lonsdale Churchyard*, capturing the view you can see today and for many years this was known as Turner's View. In January 1875 the art critic John Ruskin, who had long been a fan of Turner's work, visited the site and famously described it as 'one of the loveliest scenes in England – therefore, in the world'. He was, however, less than complimentary about the town and its inhabitants.

The view remained unchanged right up until 2003 when a local farmer had a dispute with the council. The farmer had sought planning permission to convert the barn on his land into three holiday homes but the council turned down his application, saying the development would detract from the landscape made famous by Turner and Ruskin.

Ruskin's View.

Somewhat upset by this, the farmer took matters into his own hands and painted the outside of the barn with a variety of brightly coloured paints, something that didn't require planning permission and can easily be seen by those admiring Ruskin's View. Local opinion is divided between those applauding the farmer for his bold action and those upset at the damage to the view.

38. Devil's Bridge

Kirkby Lonsdale is tucked away in the far south-east corner of the county, right on the border with Lancashire. The town sits on the banks of the picturesque River Lune and can trace its history all the way back to the Neolithic Period (around 7000 BC). In the hills above the town is Casterton stone circle, a small and almost buried stone circle containing around eighteen stones, which is also a pretty little picnic spot with lovely views.

The narrowing of the Lune at this point would have made it a natural crossing point and a number of ancient routes converge on the area, though the actual site of the original ford is not known. The importance of the town as a meeting and crossing point led to its gradual growth and expansion. One of the problems facing the early settlers was the fact that the levels of the River Lune would rise

Devil's Bridge.

following heavy rain, making it impossible to cross at the ford, a problem that was solved with the building of the bridge.

There is a debate surrounding the precise age of the bridge, with some historians suggesting it was built at the same time as the church in the town, when there would have been stone masons available locally with the appropriate skills. If this is true, then that would date the bridge to around AD 1200. Others argue that the style of the arches suggests a later date of around AD 1500, though it could be that the arched bridge we now see was rebuilt on the site of an earlier structure.

The bridge has survived so well because none of the pillars stand within the main water channel. It was the only bridge in the town until 1931 when Stanley Bridge was built to carry the A65 through and although the original bridge was no longer open to traffic, it was still in need of repair. It was listed on the English Heritage At Risk Register in 2010 but has since undergone improvement and is no longer considered at risk.

As with any ancient bridge, there's a lot of folklore associated with its name. In this case it's said that an old woman who lived on the banks of the river lost one of her cows when it wandered across to the other side and refused to come back. The Devil appeared and offered to build a bridge in exchange for the first soul to cross the bridge, assuming it would be the old woman's. When the bridge was built, the old woman tossed a bun across the bridge, which was chased after by her little dog, thwarting and incensing the Devil.

The town remains popular with visitors, especially on Sundays when it acts as a meeting point for bikers and the focal point for many is Devils Bridge. One of the main challenges currently facing the bridge in recent years is the dangerous 'sport' of tombstoning, where people jump from the bridge into the river below. The practice continues despite the fact it is illegal and there has been one fatality and several serious injuries over recent years.

Stanley Bridge.

South West Region

39. Herdwick Sheep

Cumbria simply wouldn't be Cumbria without the smiling face of a Herdwick sheep or two greeting you as you wander around the fells. They will be forever associated with Beatrix Potter, whose love of the fells and Herdwicks is well documented, though she was far more than a rich author indulging an interest in sheep. She owned and ran a respected fell farm and hired the very best local shepherd (a man named Tom Storey) to manage her flocks for her.

They worked hard together and produced a number of award-winning sheep with Mrs Heelis (as she was known up here) involved in every aspect of the farm. She became a well-respected expert within the male-dominated world of fell farming and her death was recorded in the Herdwick Sheep Breeders' Association 'Flock Book' alongside other local breeders of repute.

Herdy in her winter coat.

Herdwick lambs.

The Herdwick year goes something like this. During the autumn, when the sheep are on the lower pastures, the 'tups' (rams) are let loose among the fields of ewes to do their duty. The ewes are then returned to the high fells where they are pretty much self-sufficient (barring particularly bad weather) through until the spring.

Throughout April and May they lamb – usually later than many other breeds – and the tiny all-black lambs fill the fells. During the summer months the sheep return to the fells as the lambs gradually change colour, eventually developing the iconic white head and dark fleece that is the Herdwick trademark (if you spot one mid-change, they look as if they're wearing mini balaclavas!) and then, come the autumn, the whole process begins again.

There's an entire language surrounding sheep breeding, so here's a very quick guide to a few terms you may hear:

Tup – ram
Gimmer – young female sheep
Hog or shearling – young sheep nine–eighteen months old before its first shearing
Heafing or hefting – the process where the mothers teach their lambs about where to graze on the fells and the lambs, in their turn, pass that on to their lambs when the time comes.

There are various gatherings and events throughout the year for farmers, with some of these gatherings stretching back many hundreds of years. These events are a hugely important part of the farming social calendar as they provide famers with a break from their usual solitary lives and a chance to catch up on local news, return 'lost' sheep and show off the best of their flock.

Winning awards for their sheep isn't just a vanity project for the farmers (although they all take a deep pride in producing a top-notch Herdwick), awards and recognition increase the value of the sheep and can have a direct effect on the livelihood of the farmers. If you love 'herdies', as they're usually known, take a look at the Herdwick Sheep Breeders Association website where you'll find a list of local Herdy farms offering B&B or self-catering breaks.

40. Wast Water

Britain's favourite view and the deepest lake in England are just two of Wast Water's claims to fame. It's not the biggest lake, or even the prettiest (an accolade that usually goes to Ullswater), but it's certainly the most dramatic, with Whin Rigg and Illgill Head rising to 500 metres and 600 metres respectively straight up from the shoreline.

One of the things that makes Wast Water so special is the sheer number of interesting fells surrounding it. Aside from Whin Rigg and Illgill Head there's the tall narrow profile of Yewbarrow on the north-west shore – an unmistakable mountain of extremes where an arduous climb is followed with a very pleasant summit ridge, and a 'what was I thinking' descent over Stirrup Crag is followed by a gentle stroll back alongside Over Beck.

Beyond the northern shore and squarely in the middle of Britain's Favourite View looms Great Gable, a mountain steeped in climbing legend and one of the finest looking fells in the whole of the National Park. At the summit is a war memorial where a remembrance service is held every year in November and on its flanks is Napes Needle, first summited in 1886 by W. P. Haskett Smith and still considered one of British climbing's classic routes.

Then, of course, there is Scafell Pike, England's highest mountain, though it's its immediate neighbour Sca Fell, which is the better looking of the two. If you fancy a hill walk with a bit of a difference, then follow the route up to Burnmoor Tarn; it's a very different landscape up there with some magnificent views of the fells.

View of Yewbarrow, Kirk Fell and Great Gable.

Wast Water reflections.

Wast Water Screes present one of the most challenging low-level walks in Britain and many a hiker has come unstuck as they pick their way through. As you make your way along the south shore from Wasdale Head, the screes build rather like Ravel's Bolero. They begin gently enough with fields and lakeside track giving way to a rockier shoreline and gentle small scree slopes, but as you continue, the scree becomes larger and larger until you're scrambling over boulders.

Many people make the mistake of climbing up the sides of Whin Rigg, but keep lower, towards the shoreline and look for the slightly smoother edges of the well-worn rocks, which mark the indistinct footpath. We're big fans of the route but only when we're in the mood for a challenge.

When you reach the far south-west of the lake, there's a bridge over to Low Wood where the footpath skirts around the woodland and leads to the official site of Britain's Favourite View. There are plenty of benches where you can pause to catch your breath and perhaps enjoy a well-earned flask of tea. If you don't fancy tackling the screes then don't worry, there's a nice easy footpath leading down from the road near to the youth hostel; just make sure there's plenty of space on your camera for all the photos you'll want to take.

41. Scafell Pike

Right, first off, let's deal with the pronunciation – a contentious topic for which it's hard to find a definitive answer. The main options are 'Scar-fell' and 'Scaw-fell'. I have an original copy of *The Journal of the Fell and Rock Climbing Club* from 1934, which has an advert for the 'Scawfell Hotel' in it, plus an advert for the New Dungeon Ghyll, Woolpack and Wastwater Hotels, all of which claim to be within easy distance of 'Scawfell'.

None of the adverts mention 'Scawfell Pike' and that's because until the 1800s the term 'Scawfell' referred to a collection of four peaks, including what we now know as Scafell Pike. The name didn't really catch on properly until

Scafell Pike (right) and Sca fell (left).

Winter walking around Scafell Pike.

the mid-1900s and there is still much debate about exactly what 'Scawfell' encompassed and who's to blame for the name change.

In an effort to settle the argument I tracked down two Old Norse language experts. The original name is thought to be 'Skalli Fjal', which roughly translates as 'bald summit' (if you've seen Sca Fell then you'll know the name makes perfect sense), but how do you pronounce it? After much deliberation they settled on 'Skalley Fee-al' with a flat 'a' as in apple so I may just start calling it 'Scallyfell Pike' and see if anyone notices...

There are a huge assortment of routes to the top, though the most popular is the route up from Wasdale Head, which is the route you will have been up if you've ever tackled the Three Peaks Challenge (more of that later). We're rather partial to the route up from Seathwaite, switching to the Corridor Route to reach the summit, but there's also a lovely route up from the Langdale Valley, which is longer but usually quieter than the other routes – it also has the benefit of a large car park and a decent pub for when you're finished.

During 2015 we worked with Mountain Rescue and mapped all their callouts for the year on an interactive map, grouping them into categories. What stood out was that the majority of callouts on Scafell Pike were for people getting lost. Being the highest mountain, it gets plenty of cloud, plus there are a huge number of well-trodden paths and it's easy to take a wrong turn. If you're heading up there, it's perhaps best to double check your map reading skills before you set off.

And finally, if you are visiting Scafell Pike as part of a Three Peaks Challenge, then do please take your litter home with you. Each year during October the Real Three Peaks Challenge takes place when groups of locals clear the main routes up the three peaks (Snowdon, Ben Nevis and Scafell Pike). In 2015 they collected 513 kg of rubbish – that's over half a ton – which includes tents, sleeping bags, camping chairs, condoms, beer cans, glow sticks and water bottles. There's a simple rule – if you carry it up, carry it down again and dispose of it properly.

42. Cathedral Cave

The awe-inspiring Cathedral Cave is situated in Cathedral Quarry, just above the Langdale Valley. It's a man-made cave and a remnant of the days when quarrying was one of main industries in the county. The iconic Lake District green slate was quarried here and along the walls of the main cave, and the small tunnels leading away, you can easily see evidence of the mining activity, including the old drill holes.

Cumbrian slate was once one of the most prestigious building materials in the country and using it as a facing stone or decoration was a symbol of wealth and status. It was used by Sir Christopher Wren in a number of his buildings and decorates the walls within Kensington Palace and other well-to-do properties in London. Originally the slate would have been hauled by packhorses over the fells to the Cumbrian coast, ready for export.

Cathedral Cave is the main cavern within a series of smaller caverns and tunnels, which these days are owned and managed by the National Trust. Much of it is open for you to explore and it's especially fun for adventurous kids, though do please take great care on your adventures and respect the cordoned-off areas.

The main cavern.

Tunnels to explore.

The main cavern is 12 metres high and was made for atmospheric photo taking – it also served as a location for the 2012 film *Snow White and the Huntsman*. In the centre is a large pillar supporting the roof, which, when viewed from certain angles, creates a superb window-like effect for framing views of the fells beyond.

Beyond that are a series of tunnels, one of which is over 120 metres long and is pitch black. If you're planning to explore, be sure to take head torches and ear protectors – not that they're still blasting, but the noise of several dozen children jumping out at each other and screaming as they scare each other silly can be headache inducing.

The cavern is also very popular with rock climbers, but only the good ones! There are twenty-six differently named climbs within the cavern, all of them 30–40 metres long, all of them graded as 'extreme' and many of them with interesting and colourful names. My personal favourites are 'Diet of Worms', 'Night of the Hot Pies' and 'Murder in the Cathedral', though there are a number of others whose names preclude them from a family-friendly book such as this.

While you're in the area it's also worth taking a short detour along to the picturesque shores of Little Langdale Tarn, the ideal place to unwind after the high octane adventures in the cave.

43. Hard Knott Pass and Fort

Throughout the summer months a steady stream of cars edge their way up and over Hard Knott Pass (or over and down depending on which way you're travelling). The road is single track for the most part with a few passing places, a lot of hair pin bends and a gradient that regularly reaches 1:4 (25 per cent) and occasionally rises to 1:3 (33 per cent).

Hairpin bend on Hard Knott Pass.

The road was originally built as a trade route linking Ambleside and Kendal with the West Cumberland (as it was then) coast. Hard Knott Fort provides us with evidence that this was an important route for the Romans while they were here. By the eighteenth century the route was being used by packhorses trekking between Whitehaven and Kendal, and during the Second World War it was used by gun carriages on military exercises.

This last activity seriously damaged the road surface to the extent that it was closed to traffic – it may not sound much to close a remote single-track road, but this is a vital east– west connection in the county and the detours were huge. Thankfully it was resurfaced and reopened in 1946, though not without its critics.

Back in the 1920s, in the early days of the motorcar, it was considered a great adventure to take your car up the worst road you could find and Hard Knott Pass, unsurprisingly, features in a number of old photographs from the era with cars doing just that. It can be enough of a challenge in modern car; one can only imagine what it must have been like trying to manoeuvre a huge beast of a car with no power steering and little in the way of suspension up and over a 1:4 gravel track with hairpin bends.

Hard Knott Fort was established in the early second century and abandoned early in the third century. After that it offered shelter and possible accommodation to passing travellers. It was one of the most remote and isolated forts in the country, though perhaps the breathtaking views made up for some of the discomfort. It was established to protect the important trade route that connected the Roman towns (and forts) in Ambleside (Galava) and Ravenglass (Glannoventa).

Hard Knott Roman Fort.

Unlike many ancient forts there's plenty still to see at this one with low-level walls and rubble still outlining many of the buildings. Archaeologists have identified a bath house, courtyard, granaries, barracks and a range of different residences within the walls of the fort, which provided accommodation for a garrison of around 500 soldiers.

The ingenuity of the Romans is still easy to see too – the granaries were built on raised wooden floors to provide ventilation. In the Headquarters building are the remains of a 'tribunal' the platform from which the commanding officer would issue the orders for the day and preside over other official duties. We still use the word in a similar sort of context, so the next time anyone asks you what the Romans ever did for us...

44. Coniston Water

Coniston Water is a place made famous by a number of people: John Ruskin lived in Brantwood at the north end of the lake and Arthur Ransome's children's classic *Swallows and Amazons* was inspired by holidays in the area with Peel Island at the south of lake featuring as Wild Cat Island.

Setting new records on Coniston Water.

Steam-powered speedboat.

Arguably the most famous event in the lake's history occurred on 4 January 1967 when Donald Campbell died attempting to set a new world water speed record. Donald was following in the footsteps (or tyre tracks) of his father Sir Malcolm Campbell, who had set a series of world land and water speed records.

Donald Campbell gradually pushed the boundaries and increased the water speed record from 202.32 mph (325.60 kph) in July 1955 to 276.33 mph (441.71 kph) in December 1964, and in doing so, in 1964 he became the first and only person to set both a land and water world speed record in the same year (his land speed record had been set on the lake bed at Lake Eyre at 403.10 mph (648.73 kph).

In an effort to raise more publicity for his proposed 'rocket car', which would smash previous land speed records, he decided to have one last attempt at a water speed record and so came to Coniston. During November and December 1966 they trialled the boat on the lake but suffered from poor weather and a number of mechanical setbacks. On 4 January 1967 the boat and weather conditions appeared perfect and on his first run along the measured kilometre

he clocked a speed of 320 mph (500 kph), finally breaking the coveted 300 mph he had been hoping to achieve.

Rather than wait to refuel and allow the water to settle, he decided to head back out immediately and clocked a speed of over 328 mph (528 kph) before the boat became unstable, flipped, broke up and sank. His family asked that the site be respected as his grave and this continued until 2001 when, with the permission of his daughter, his body was located and buried at St Andrew's Church in the village.

But this wasn't the end of speed events on the water; every year during early November Coniston Power Boat Records Week takes place with boats from all over the country converging on the area to push their limits and set new records over a measured kilometre. The event is the only one of its kind to bring together all classes of boat and it's a fantastic event to watch, even if you're not knowledgeable about boats.

There are plenty of viewpoints along both shores of the lake, all of which afford excellent views of everything from tiny hydroplanes to large offshore power boats racing past – there was even a steam-powered boat in 2016. The event began in 1970 but moved from Windermere in 2005 when speed limits were imposed making racing impossible.

45. Duddon Valley

We could get into hot water with a lot of people for spilling the beans on this particular Cumbrian gem, as it's a place that's popular with locals seeking a bit of peace and quiet away from the main fells. It's just a stone's throw from the Coniston Fells (if you happen to be good at throwing stones) and the easiest way to describe how to get there is to tell you to 'turn left at Torver' – there's a steady flow of traffic along the A5084, most of which turns right at Torver and heads towards Coniston, but if you turn left and then follow the steep and winding 'Old Rake', you can enjoy a very different landscape.

Our favourite walk starts by dropping down through the woods to Appletree Worth Beck and a very pretty stone bridge. There are the remains of an old farmstead next to the beck and evidence of a ford and five large stepping stones, suggesting that this was an important crossing point. Just to the south is The Hawk and the remains of an Iron Age settlement. The site is heavily overgrown but contains the remains of five round huts and possibly some animal pens. It's not surprising that this sheltered valley, with its plentiful water supply and relatively easy access to the coast, would have been popular with early settlers.

Continuing on through the woodland brings you to another much higher bridge, this time over the River Lickle at Stephenson Ground, with a number of

Appletree Worth Beck.

potash kilns dating back to the eighteenth century hidden in the undergrowth. Farmers in the area were known to have produced potash, in order to supplement their income, by burning potassium rich green bracken.

From Stephenson Ground the path continues on along Long Mire and around and down into Seathwaite. The route offers superb views of fells, and there's a perfectly positioned pub where you can sit outside and make the most of the views on a sunny day. There have been many industries associated with the Duddon Valley (or Dunnerdale) over the years including bobbin mills and quarrying, and the valley has a long tradition of sheep farming with plenty of Herdwick and Rough Fell flocks still in the valley.

Many of the farms in the valley date back to the seventeenth century and Under Crag farm, which lies along the route up onto Walna Scar Road, was the birthplace of the Reverend Robert Walker, known as 'Wonderful Walker', who served as curate in the village for sixty-seven years until his death in 1802, aged an impressive ninety-three years. Holy Trinity Church, where he served, was completely rebuilt in 1874 and the 'Wonderful Walker' was immortalised by Wordsworth in one of his 'Sonnets from the River Duddon'. Look out for the sheep clipping stone and sundial dedicate to him along the route.

The route then follows Walna Scar Road for a short way – an old trade road between the quarries in Coniston and the Duddon Valley – before looping back down over Natty Bridge to Simpson Ground and the short walk back to the start.

Duddon Valley view.

46. Ravenglass & Eskdale Railway

The Ravenglass & Eskdale Railway is known locally as La'al Ratty – old Cumbrian dialect for 'small train' – and it's an absolutely brilliant day out. The clue is in the name with the railway running from Ravenglass, the only coastal village within the National Park, all the way up to the foot of the Eskdale fells. The journey is 7 miles long and takes forty minutes to wind its way through the breathtaking countryside.

There are plenty of ticket options to suit your mood – you could opt for a single ticket part or all the way to the top, allowing you to follow one of the many footpaths back down to the coast. If this takes your fancy, get yourself a copy of *Walks from Ratty*, a compilation of walks put together and illustrated by Wainwright, who was a huge fan of the railway.

If you're feeling a little lazier then a simple return might suit you better, with time to stretch your legs around Eskdale, or enjoy a coffee and a cake at the café. Or you

Winding through the Eskdale Valley.

could go for the all-day ticket and ride up and down the line as many times as you want, swapping seats and sides on each journey to enjoy a variety of different views.

The line was built in 1873 and was originally used to carry haematite ore from the quarries around Boot down to the coast at Ravenglass, where it was transferred onto the Furness Railway and on down to Barrow. The mainline station is still right next door to La'al Ratty and it's a great way to arrive – the train companies often offer special combined tickets, saving money on your trip.

It became the first public narrow gauge railway in England when it opened to passengers in 1876, connecting remote hamlets and villages with the coast and main railway line. A drop in passenger numbers combined with a drop in haematite production led to the closure of the line in 1913, with the track and some of the rolling stock falling into disrepair.

In 1915 the line was bought by Narrow Gauge Railways Ltd, who were looking for somewhere to test their miniature locomotives. They relaid the line, changing it to 15 inches, and the first section was reopened in August 1915. Although ownership of the line changed hands over the years, it remained open to passengers throughout.

The Ravenglass and Eskdale Preservation Society was formed in 1960 and successfully bought the line at auction. Since then a lot of work has been undertaken to renovate the line, improve rolling stock and add visitor facilities. Although there are a number of permanent staff, the line relies on a team of volunteers, helping prepare trains and assisting visitors in the summer, as well as carrying out clearing work and track repairs during the winter months.

La'al Ratty steam engine.

47. Eskmeals Dunes

When it's a busy bank holiday and we fancy a trip out and about, we usually head for the Cumbrian coast because, despite it offering miles of uninterrupted views, it's usually pretty quiet even at the peak of the summer season.

One of the jewels of the Cumbrian coastline are the stunning Eskmeals Dunes, another of Cumbria Wildlife Trust's wonderful nature reserves. The dunes cover an area of over 165 acres (67 hectares) and lie along the coast about halfway between Barrow and Whitehaven. As a coastal site, access to it can be tide dependent, with the main road from Newbiggin and footpath into the site underwater for around an hour either side of high tide. Also, the land is still used by the MOD as a firing range (usually from Monday to Friday) so it's important to call ahead or check their website before you set out. If you turn up on spec, DO NOT enter the reserve if the red flags are flying.

The site is usually quiet with parking in a nearby layby; access to the site is across rather boggy land but once you're onto the dunes there are easy paths the whole way around. Of course there are more challenging paths up and over the dunes and the site is an excellent place for the younger members of the family to

Above: Eskmeals Dunes.

Left: Ringed Plover.

burn off some excess energy – though do keep away from any fenced-off areas, usually done to protect ground nesting birds during the spring months.

The views from the site are spectacular in every direction, especially from the tops of the higher dunes. Away out to sea you can see the Isle of Man on a clear day, across the estuary is picturesque Ravenglass and rising up behind you are the imposing Lakeland Fells.

For those into marine vegetation there are a good variety of plants to spot, especially the very pretty wild pansies that bring colour to the dunes in the early days of spring. As you would expect from a nature reserve, there are a good variety of birds to see all year round along the varied shoreline.

The dunes at Eskmeals have built up as a result of sea and river action over many thousands of years and, in the glacial sediments in the surrounding areas, evidence of settlements dating back to the Mesolithic era have been found. A variety of flints have been discovered, with the stones on the beach providing a useful supply of raw materials. Archaeologists have also identified a number of hearths, or pits, which may have been used for food storage and some ancient channels that may have been dug to assist drainage.

There is also clear evidence of Romans in the area. Just across the estuary at Ravenglass are the remains of a Roman bathhouse, one of tallest surviving Roman structures in Britain.

48. Cumbria Coastal Railway

This really has to be one of the most overlooked gems in the county. Cumbria has a magnificent coastline and a railway that runs pretty much the whole way around it. You can hop on the train at Lancaster, Carnforth or Grange-over-Sands and stay on it the entire way around to Carlisle, with dramatic scenery appearing around every bend, whichever side of the train you're sitting on.

The Kent Viaduct at Arnside.

It begins gently along the first stretch as you skirt around the vast expanse of Morecambe Bay, crossing the Kent and Leven viaducts, huge skies and the vast empty spaces of Morecambe Bay on one side and the gentle rise of the southern fells on the other. As you make your way around past Barrow and Millom and on up the west coast, things become more dramatic with the high Lakeland Fells and views across the Irish Sea and the Solway Firth vying for your attention from opposite sides of the carriage.

The whole journey takes around three hours and after a short break in Carlisle you can either return back the way you came or take the quick route back down the West Coast mainline. Throughout the year they also run a series of steam trains along the route, though these need to be specially booked.

The railways were built during the late nineteenth and early twentieth century to connect the industrial ports of Whitehaven and Barrow with the rest of the UK and much of the early traffic was goods rather than people. As is the way for many things, eventually it became too expensive to transport goods and materials as cheaper products began to arrive by sea at less remote ports, so transport of materials began to dwindle.

To make up for the lost income the train companies turned their attention to the tourist trade and began running ferries across from Fleetwood and Morecambe to connect with trains near Ulverston. These trains, in turn, connected with the Lake District ferries, such as those on Windermere, to provide day trips – the Lakeside & Haverthwaite line, which still runs today, is a remnant of this. Some rail branch

Coastal railway at Whitehaven.

lines closed down and fell into disrepair before being reborn as footpaths and cycle routes – if you're after a small and properly hidden little gem seek out the Sandside cutting just along the estuary from Arnside, a very short but impressive walk.

Talking of footpaths, if you don't fancy staying on a train for three hours then you can use the route to connect sections of the Cumbria Coastal Way, the 182-mile (293-km) footpath that follows the coastline from Silverdale in the south to the Scottish border in the north. Or you could use the trains to access 'forgotten' fells like Black Combe in the south-west corner of the county. There's a lovely route up the fell from Silecroft Station, with a walk on the beach and a decent pub at the finish where, because you've taken the train instead of the car, you can enjoy a well-earned beer – days out don't come much better than that!

49. The Hoad

The Hoad, or John Barrow Monument to give it its proper name, is one of those 'what on earth is that?' gems that puzzle the first time visitor to the area. It sits on top of Hoad Hill, just to the east of Ulverston, and was built to commemorate Sir John Barrow, a founder member of the Royal Geographical Society, who was born in the town and for whom Hoad Hill was a favourite spot. His two sons laid the foundation stone in 1850 and it was finally completed in January 1851.

The monument is a 100 feet (30.5 metre) scale replica of the third incarnation of the Eddystone Lighthouse (Smeaton's Tower, which now stands on Plymouth Hoe in Devon) and although it was intended as a seamark, a stipulation from one of the original donors said that it should never have a functional light.

It cost £1,250 to build, with money raised by the public, and is constructed from limestone blocks quarried from Birkrigg Common just a few miles to the south-west. It's a Grade II-listed building but in 2003 it had fallen into disrepair and had to be closed to the public. Luckily the local town council was successful in a bid for Heritage Lottery Funds and during 2009/10 it underwent a major renovation costing £1.2 million, which restored it to its former glory.

A flag is flown next to the tower on the days it's open and although there is no charge for entry, a donation is always welcomed. A visit to the top is not for the faint-hearted; once inside there are 112 stairs winding around the inside of the tower leading to a viewing platform at the top. One hundred and twelve stairs may not sound many but they're open, mesh stairs secured to the walls with large bolts and with a large drop down the centre. Although they are perfectly safe, I must admit I clung firmly to the handrails the entire time!

From the top of the tower the views are immense with a breathtaking panorama showing off everything that is great about this corner of the county.

Left: The Hoad.

Below: Hoad Hill from Birkrigg Common.

To the south you can see all the way down to Blackpool Tower, while to the north and east are the Lakeland Fells – particularly stunning during the winter months when they are often snow-capped.

For a lovely walk, park in Ford Park and follow one of the assortment of paths to the top – they all go upwards but some of them do so rather more steeply than others. Once you've finished admiring The Hoad, take the path leading away behind the monument and follow it through the fields around the back of the town, eventually returning into Ulverston along the banks of Gill Banks Beck. You can then explore the town and find out more about its other famous son, Stan Laurel.

50. Morecambe Bay

It's hard to know where to start with Morecambe Bay because there's just so much to tell. We wanted to include it as a Cumbrian gem even though, technically, some of it is in Lancashire, but it's such an overlooked part of Cumbria in every sense of the word. The bay is 120 sq miles (310 sq km) of intertidal sands, which never stay the same from one tide to the next, and it is one of the most important migratory stop-over points in the whole of the UK.

The bay was the original crossing point into what is now south Cumbria, but was then known as Lancashire North of the Sands (it only became Cumbria when the administrative boundaries were moved in 1974). Despite there being many guides who were paid to help people navigate across, there were many tragedies, usually down to a combination of poor weather (it's pretty featureless out there if the mist comes down), racing tides, moving sandbanks or guides perhaps not being as competent as they made out they were. These days if you want to cross the bay, the only way to do it is as part of one of the many guided walks that take place during the summer months.

Morecambe Bay at low tide.

Walking across the bay isn't the only thing people did; once it was very popular to swim across, with many races being held. On the British Pathé news website there is an excellent report of a race from 1937, with the winner crossing the 12 miles (19 km) between Grange-over-Sands and Morecambe in just over three and a half hours. Across the bay on Morecambe prom is a lovely sculpted memorial to Commander Charles Gerald Forsberg, who was a prodigious open water marathon swimmer and crossed the bay a total of twenty-nine times.

These days you're less likely to find swimmers in the bay and more likely to find seals. At low tide, over on South Walney nature reserve at the southern tip of Walney Island, large numbers of grey seals haul out onto a remote beach. The exciting news is that whereas they only used to use the site for hauling out, over recent years there have been seal pups born there, which shows just how well the seals are thriving in the area.

Bird life is also brimming over all around the bay with thousands of waders making the most of the rich shallow waters. For your best chance of spotting birds check the tide times and aim for the prom at Grange-over-Sands an hour or so before high tide. At low tide the birds are far out in the centre of the bay but the incoming tide pushes them towards the shore, making them much easier to spot – an evening stroll just isn't the same without the call of curlews and oystercatchers in the background. For migratory birds the best times are dawn and dusk from mid-autumn through to spring.

Sunset over Morecambe Bay.